PRINTING

WITH NATURAL DYES

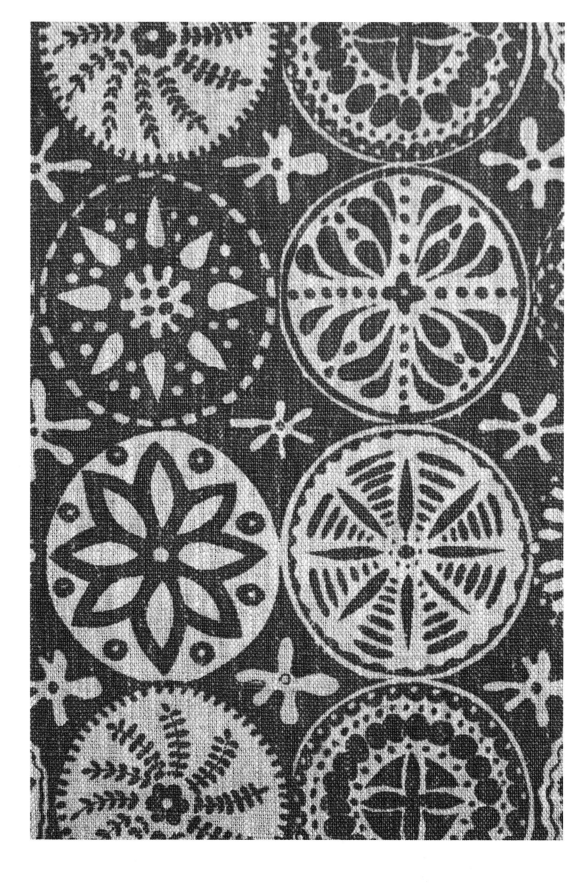

Nicola Cliffe

PRINTING
WITH NATURAL DYES

THE CROWOOD PRESS

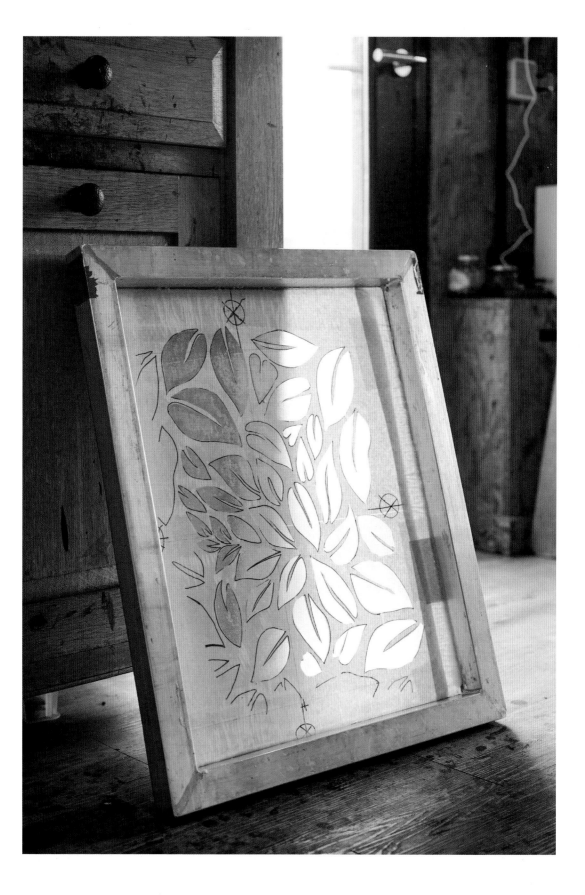

CONTENTS

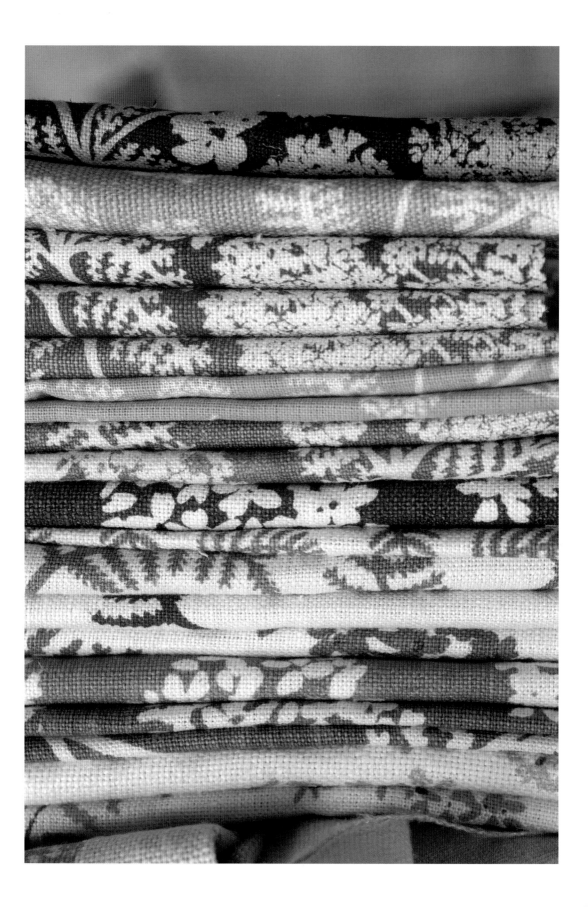

INTRODUCTION

Welcome to the world of printmaking and the beauty of home-made natural dyes. You may be completely new to printing or looking to discover new techniques – whatever your background, this book aims to inspire and foster new skills as you embark on your printmaking journey. I hope, like me, you will discover a passion for the wonder and richness of natural dyes and learn new print methods for making anything from a simple birthday card to undertaking major projects including curtains and furnishing fabrics.

I have been on a mission to introduce plant dyes into our homes for more than ten years and it is a pleasure to share my discoveries and printmaking techniques with a wider audience. There is no doubt a resurgence of interest in natural dyes is timely. In our current world we need to aim for a circular economy, a model of production that involves sharing, leasing, reusing, repairing, refurbishing and recycling existing materials and products for as long as possible. The best methods we can use are those that produce items that are sustainable and minimise waste. What could be more ethical than hand printing with natural dyes?

To get you started, I have included a general overview of what equipment and sundries you will need for several printmaking processes, guiding you as you create your own patterns to turn into prints. Within these pages you will find a wealth of information about plant dyes, which colours are best and how to turn them into eco-friendly, easy-to-make printing pastes. Each chapter sets out projects and suggests ways in which you can experiment to achieve different results. By the end of the book, I hope you will feel confident to draw and transform your own designs and patterns using inspirational resources you have discovered and mastered for yourself. You can either read the book from start to finish or dip into it as a useful reference source as your skills improve.

The printmaking processes explored within these pages include screen printing, block printing and eco printing. I must admit I am most at home with screen printing – I love the speed of print production once the screen is made and the crispness of the finish that is accurately reproduced in every print.

Block printing is a therapeutic process that embraces errors and mistakes more than any other printing method. In fact, imperfections make the craft come alive, as confirmed by Michael Silver, Director of Christopher Farr Cloth. He refers to the work of Barron and Larcher, two women who revived block-printed fabrics in the 1920s and 1930s to create an amazing textile collection: 'They were not trying to make bold statements, yet the designs had huge presence and the use of natural dyes, which restricted the colour palette, resulted in nuances, imperfections and tonal irregularities that enhanced the beauty of the work.'

Fabrics printed with Madder Cutch & Co's natural dyes.

Eco printing, as its name suggests, is perhaps the most environmental way of getting plant colours onto cloth. In this book I explain how to use plants directly onto your choice of material employing a variety of new and old techniques. The effects are stunning and unpredictable and yet this is the easiest process to embrace.

My own introduction to natural dyeing came through chemistry, and I left a long career in teaching to go to art college as a very mature student. It was at the Chelsea College of Art and Design, and with a love of all things William Morris, that I was finally able to indulge my passion and research natural plant dyes in depth, to learn their ancient history and how to use them. I spent years searching for recipes and methods that I could borrow and update and quickly discovered there was more than one way to achieve spectacular results. Eight years ago, I launched my business Madder Cutch & Co, specialising in screen printing linen for home furnishings and running workshops for creative people. I am also very keen to support textile students looking for work placements at the start of their creative journeys. I am constantly inspired by other printmakers and designers and am indebted to all those who agreed to share their skills in this book.

As you embark on your own printmaking journey it is worth looking at the history of natural colours. For most of human history the only sources of colour were plants, some insects and pigments from the earth. Techniques for dyeing cloth were developed in every part of the globe, the knowledge and skills carefully being passed down through generations and over the centuries. But nothing seems to have been documented until, according to Simon Garfield, in 1823 in New York, William Partridge published *A Practical Treatise on Dying of Woollen, Cotton and Skein Silk*. It was only at this point that many skilled and well-practised recipes became available in a written format. A change then came around 150 years ago when the first synthetic dyes were discovered and made by the chemist, William Henry Perkin.

Different techniques and processes have since been invented depending on available local resources and materials. Of course synthetic colourants have replaced natural dyes for

numerous reasons – in my opinion not necessarily because they look better – but for reasons of practicality, production, application and cost.

There is no doubt that natural dye colours are beautiful, but they will never once again become our primary cloth colourant. However, I am heartened by the resurgence of interest in natural dyes and they are certainly being used more and more by craftspeople and those with the best eye for colour. You are now part of that journey, drawing from traditions and histories that have gone before and taking them with you as you travel forward.

I have put together the basic components you need to start printing with plant dyes and I hope that the projects, information and insights in this book will give you the inspiration and confidence to embark on your own print projects. Do let me know how you get on and I hope you will share your ideas with others in this worthwhile, and creative, craft community.

Nicola Cliffe

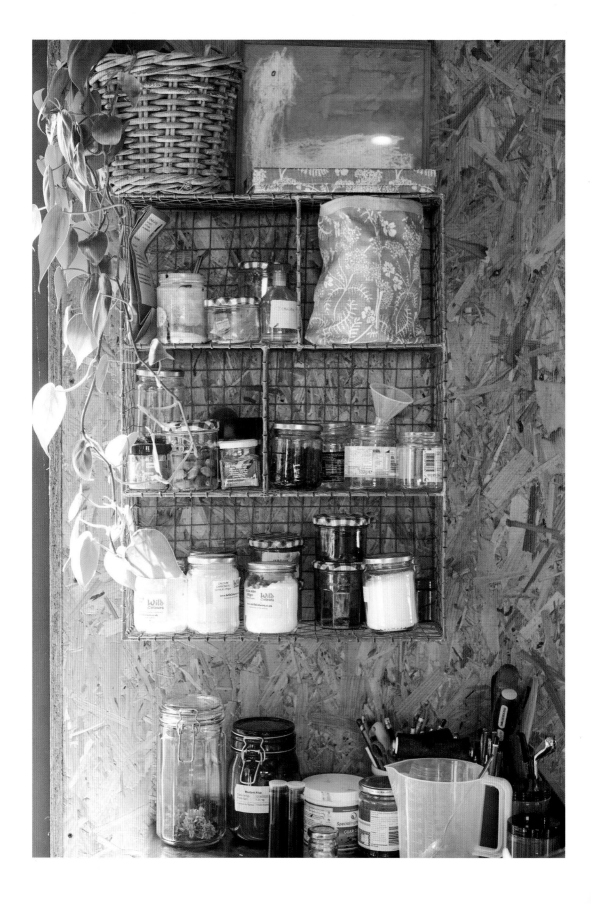

THE WORKSPACE

The main purpose of this book is not only to get you printing with natural dyes, but also to give you an opportunity to experiment with different techniques in order to find the ones you love the most. As you develop, you will organise your space and workroom to suit your chosen craft. While some of the equipment will vary with each printing process, your workspace can easily be adapted for all techniques covered in this book. Essentially you will need three main areas: a wash area, a dye-making area and a worktable.

Of course, a spacious, well-lit and stocked studio is the desired set-up, but there is nothing wrong with starting out on a thoughtfully prepared kitchen table, with all of your accessories and equipment close to hand in a storage box that can be pulled out when you are on a mission to print yourself something.

Next, I am going to describe the areas that would be useful to have in your 'ideal' workroom, if you have the space (even if you don't, you should be able to see how the zones will work). For example, you can do all of the block carving, mixing and testing on a print table; you just need to work efficiently, cleaning up and packing away as you go. This can be scaled and refined, depending on how your processes develop and how addictive printing becomes for you.

WORKROOM SPACE

It is important that you are well organised and have everything to hand for your preparations in your workroom – whether it is your kitchen or a room especially for crafting. If you are going to prepare your dye pastes, cut blocks and screen print in your kitchen, it is important not to mix cooking utensils with ones used for mordanting and dye plant mixing (*see* Note overleaf). It's a good idea to have all of the essentials close to hand and to set up your table and wet area within a reasonable proximity to each other.

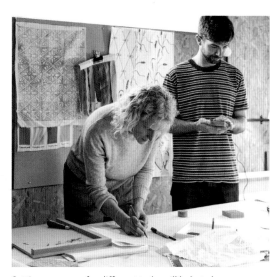

Setting up zones for different tasks will help to keep your workspace tidy and clean. The main printing table can be used for designing and preparations prior to printing.

Storage jars on shelving. Your workspace will be a nicer place to work if you are well organised and know where to find everything.

When working with paints, inks or dyes, it is sensible to be in a space with a washable floor; one that you are not too bothered about if it gets stained. You shouldn't be making much mess – when printing it is important to work as cleanly as possible – but any surfaces that are vulnerable or precious should still be protected and easy to clean.

The best set-up would be a designated room with a good solid table, plenty of natural light and ventilation, and a sink with a large draining board and running hot and cold water. A separate table that can be used to set up the hotplates and have all of the components to hand for mixing up the dye pastes is useful. The print table can be used for artwork and carving blocks and then transformed into a printing table at the printing stage.

> NOTE: When working with inedible substances, it is important to be careful and treat all substances that are not for normal kitchen cooking as chemicals. Take care to cleanse surfaces and keep dyeing utensils separate from your usual cooking ones.

MIXING AREA

This area will be important as you learn how to extract the colours from dye plants and turn them into a suitable printing medium. You will need to have enough space to house a portable tabletop stove, some weighing scales, and mixing and grinding vessels, as well as some storage pots for the dye plant material. A shelf that is out of reach of children is a good idea for all of the 'chemical' components.

Storage Pots

Good storage pots are essential. While glass containers are the most sustainable, we do need to be careful when handling them. Kilner-style jars, used washed-out jam jars and similar are all worth saving for this purpose.

When the printing pastes are made and ready to be used, a suitable vessel will be needed to hold the ink to take to the printing table. It might make sense to invest in some standard plastic pots with good snap lids (unfortunately plastic still makes the best pots). As long as they are used again and again, it's not going to be a disaster.

Store all chemicals and sundries on a shelf out of the reach of children and with a clear labelling system.

Recycled jam jars and Kilner-style jars are good for keeping dyestuffs dry and organised.

Steaming Vessels

A steaming vessel is needed when eco printing and printing with direct dye pastes. The fabrics will need to be steamed to fix the colours into the cloth. It is a very easy piece of kit to assemble using a large pan but may only be suitable for steaming smaller pieces of fabric. If larger pieces need steaming, you can adapt other vessels for this purpose. I find a catering-style water heater works well to take larger rolled-up pieces of fabric, using chicken wire that has been moulded to make a stand inside it above the water level.

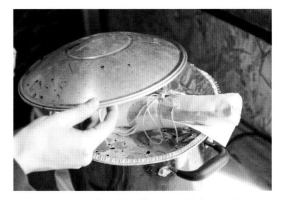

Steaming pots can be adapted. Here a tinfoil tray with pierced holes works well for smaller printed pieces.

> **NOTE:** It is very important that your steamer doesn't boil dry, so keep checking the water level when you are carrying out the steaming process.

Labelling System

It is good practice to put as much information on the labels as possible, for example where the material comes from, dates collected or to be used by and obviously what it is.

Mixing Utensils

These utensils will be similar to those used in the kitchen. Repurposed ones that are not good enough for cooking any more are always a good find. I like to keep mine in utensil-type pots, storing wooden spoons and spatulas in one and metal measuring spoons and stirrers in another.

Waste Bin

A large waste bin divided into compost, recycling and other is a good idea in this area.

Damp Sponge

I like to have a damp sponge on the table when I am working with dye extracts, just in case of spillage.

TESTING AREA

A small space could be given over to a testing station that is set up to test colours and consistency. It could also be an area in which you keep your records and experimentation notes. A pinboard or rail would be handy to hang test prints to dry.

If you intend to be consistent with the colours that you make to print with, a good record-keeping habit is essential. This area could just be a small space at the end of your table or a shelf on the wall for books and tiles.

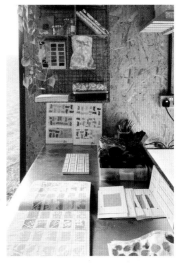

A testing area is a good place to keep notes and records.

ARTWORK AND PRINTING TABLE

You can use the same table for artwork and printing. The block carving and stencil cutting steps are slow processes so you will need a good table at the right height for sitting down. A cutting mat and a heavy-duty cloth to cover the area (for ease of cleaning up debris from carving the blocks) are handy. Good lighting is essential for close-up work; when tracing patterns a small light box will be useful.

A heavy, sturdy table is best for printing – one that will not move when you lean on it and that is big enough to take all the pieces of fabric you want to print. The top will need to be covered to give the table a slightly cushioned surface, which will help to imprint the design onto the cloth without it slipping. To achieve this, a blanket or towelling fabric can be placed under a calico or canvas cover. The covers can be washed from time to time to keep the heavier underfabrics clean. The cloths can be fixed to the table with bulldog clips, and if the underfabrics are quite heavy and the tabletop is not too slippery, they tend to just stay in place. (There are various anti-slip table coverings that can be bought if necessary.)

It's always more relaxing to work in a space that is tidy, where you have room to move around, so plan for plenty of storage space and organise the printing area so there is enough room to manoeuvre all the way around the print table. The area under the table can be used for storage and to help keep things neat. I always think it is better to print standing up, therefore chairs and stools should be kept out of the way when printing.

WASHING-UP ZONE

If, like me, you don't like getting your hands too dirty and stained, a pair of surgical gloves can be worn. However, it can often be tricky to keep these clean and you are also more likely to contaminate your surroundings because you can't feel the ink on your hands. A deep sink with warm running water, some nice soap and a clean towel to hand is always my preferred option. A sink and draining board are essential – it's the space where dirty things are allowed to land.

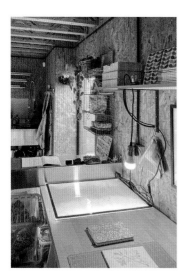

A light box can be useful when tracing intricate designs.

Here the table has a cushioning layer and a calico protective layer, ready to pin or clip down.

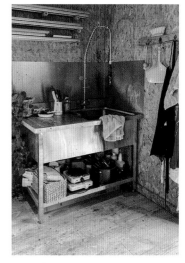

The sink and draining board is the most important area of your workroom.

Washing-up Zone

- Aprons
- Tea towels (old ones no longer good enough for the kitchen)
- Hand towels
- Dustpan and brush
- Washing-up cloths or sponges
- Handwashing soap
- Washing-up liquid
- Pots to stack drying utensils
- Scrubbing brush
- Scouring pad

Mixing Area

- Hob/heating element (this can be your normal kitchen cooking top, but a portable electric hob in a designated zone is more desirable)
- Steaming pot
- Muslin cloths for steaming
- Weighing balance (electronic ones that measuring to one decimal place are ideal)
- Measuring vessels (or folded scrap paper can be used)
- Large pans (jam-making pot)
- Mixing bowls (ones discarded from the kitchen)
- Wooden spoons
- Tongs
- Wooden or silicone spatulas
- Storage pots
- Ink tray

Table

- Layer of insulation material (curtain wadding or a blanket)
- Calico or canvas, large enough to cover table
- Bulldog or artboard clips (if necessary)
- Light box (optional)
- Overhead light or a task light
- Cutting mats

Block-printing Kit

- Woodblock carving tools
- Pencils and rubbers
- Artwork materials
- Woodcutting tools
- Standard linocutting tools
- Woodblocks
- Lino blocks
- Tracing paper
- Sponges
- Bench hook

Screen-printing Kit

- Screens of various sizes and mesh counts
- Squeegees to suit screens
- Spatulas
- Newsprint paper
- Cutting mat
- Craft knife (blade 11)
- Masking tape
- Fabric marker pens
- Scissors

Eco-dyeing Kit

- Muslin cloth
- String/elastic bands/bulldog clips
- Cardboard or wooden roll
- Jam jars
- Spray bottle
- Wooden board
- Hammer
- Scissors

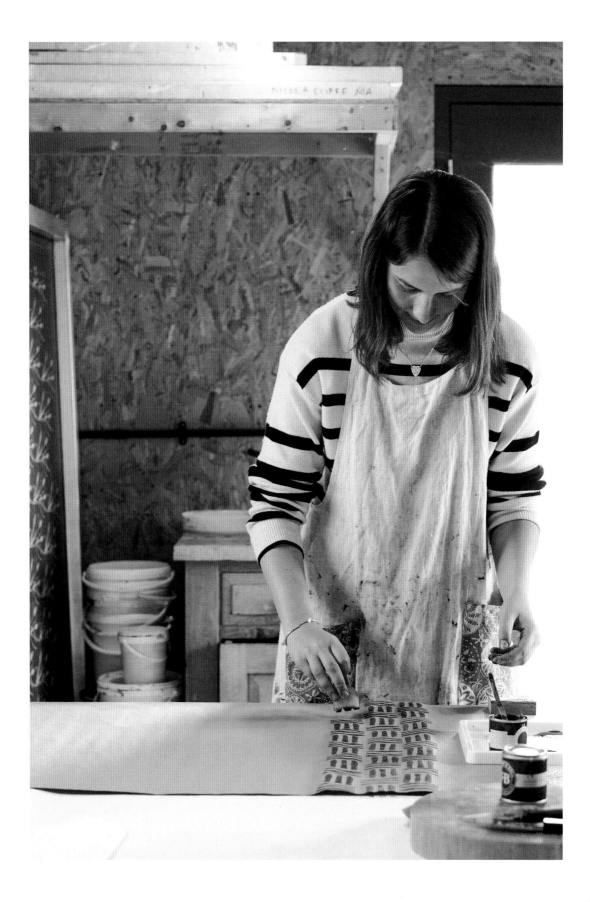

RELIEF PRINTING

In relief printing, the image to be printed makes up the surface of the block and the area not being printed – the negative space – is cut away from the block material. The raised surface is then inked and pressed onto the paper or fabric to leave a mirror image of the design.

Relief printing is quite an extensive craft and it can be divided depending on what the block is made from, how the carving and printing process is carried out, what material is being printed and what inks are being used. In this chapter you are going to use potato, wood and lino as blocks; print on cellulose fibres, like cotton, linen and paper; and will only be using home-made natural dye pastes. Your own unique and inspired drawings will be the centre-piece of the final printed patterns.

The earliest known forms of printing actually happen to be block prints on fabric and then later on paper. Wood block printing originated from China during the Tang dynasty (AD618–907); the technique moving to Asia and then further afield. There is a long and amazing history of block-printed fabrics from all around the world – up until the late 1800s these were all printed with natural dyes and pigments.

Printing napkins with carved wooden blocks.

Speronella Marsh, Hare's Tail

Today block printing is still going strong, being an accessible way to print large or small pieces of fabric. I had a chat with block-print artist Speronella Marsh of Hare's Tail, and she told me what she loves about the process, what inspires her and a few other insights to explain why this age-old tradition is still a thriving industry.

Speronella hand carves her designs into lino and mounts them onto wooden blocks, ready to print onto beautiful antique linens. Growing up in Rome, the 'washed-out' hues of the buildings that haven't been painted for 100 years or more and the natural form were a constant inspiration to her. This perhaps explains why she loves the imperfections that are part of the block-print process. She says the methodical nature of the printing is a way of meditating:

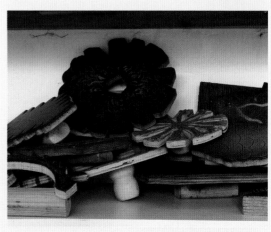

A selection of printing blocks in Hare's Tail printing studio.

> When I enter the studio, I lose track of time and am completely immersed in my work. It's a lovely, invigorating way of emptying your brain.

In Shropshire, Speronella has her studio very conveniently located just across the road from where she lives.

> It's a simple space with no internet and terrible phone reception but I love it and it's perfect for what I need. It enables me to switch off from everything else and focus on printing.

Her design process begins with a visual trigger like a leaf in the garden or a picture in an exhibition:

> It's this first visual instinct that takes me back to my studio. As soon as the design is carved into the wood I will test print it on paper first, because I print on antique linens. Once on paper I often know immediately if it's going to work or not. The design process can be difficult, as my initial inspiration is so quick and visual it can be hard to translate that thought into a block.

Speronella handprinting antique linen.

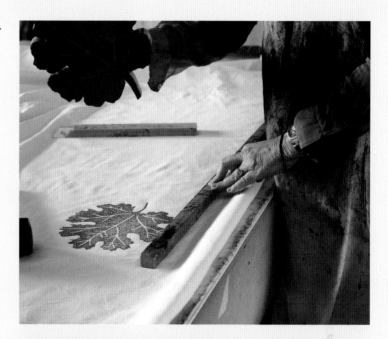

Speronella's cosy studio in Shropshire.

Louisa Loakes

Louisa Loakes is a London-based artist and block printer, working out of her studio in Peckham. Inspired by the textiles of India, she began to explore the traditional printmaking methods and found a connection between the process and her own abstract artwork: 'A natural part of this process produces irregularities; these honest but sometimes imperfect marks are what I love about a piece of block-printed fabric. As the block twists and turns across a length of fabric, a rhythm runs through it, giving an energy and life.'

I asked Louisa to explain how she goes about producing new designs and to take me through her steps to completing a printed piece of fabric.

I like to approach my patterns like a painting or a charcoal line drawing. Play, experimentation, intuition and making mistakes are all important parts of the process for me when designing new work and a new block.
The repeat isn't always at the forefront of my mind. It can become overwhelming if you think about it too much. Keeping it free and playful always works best.

I hand carve all my own blocks and tend to work by cutting straight onto the lino like a sketch. This sketch usually ends up being my final piece. By working in this way, I feel there is an honesty and freedom that can come out in the design. I like to try to have an intuitive approach to my work when designing and I don't ever like to use a computer in the process; everything is very hands on.

When the block has been carved into lino and mounted onto wood, it becomes a beautiful tool that I form a relationship with, like a good friend.

The printing process is really physical. You have to always stay connected to the block and the fabric; it is repetitive, rhythmic and often meditative. There is lots to balance; from the ink – its consistency to the amount you apply to the block – to positioning the block and applying the right amount of pressure. Printing a length of fabric is always exciting, but it does come with pressures too, which keep you on your toes. There is always the chance that you could drop the block or accidently print the block the wrong way round. When printing, your eye is your guide that speaks to your hand; they rely on each other. When I stand back to look at the finished long length of printed fabric, I finally see the painting I had planned.

This quote from Phyllis Barron sums up the design process for Louisa, and it's one that I whole heartedly agree with: 'Success depends not on learning what is difficult, but in finding out what is easy.'

Louisa's work builds on simple geometric forms. She combines these with delicate lines of a monochromic colour palette, which are broken with a signature dash of painted colour – usually burnt orange.

As Louisa says, 'Adding the painted colour gives the pattern another layer and energy, another spirit running through it.'

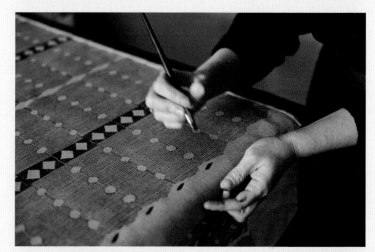

Louisa Loakes' 'saffron spot' fabric.

GETTING STARTED

The Printing Blocks

Traditional wooden printing blocks were generally made from the end grain of hardwoods like box and pear, but any slow-growing wood with a tight structure and limited knots and imperfections is acceptable, including holly, sycamore and lime. Although these woods make it easy to cut fine detail into the blocks, really fine details are not always needed when printing on fabrics, and nowadays there are lots of alternative, cheaper woods that can be used.

You can buy wooden blocks ready prepared for carving or you could even source your own from offcuts in wood stores. Softwoods or offcuts may need sanding and seasoning preparations before you cut the design, especially if you want it to do a lot of printing. Plywood, including Shina, is a very good alternative, with a flat surface that doesn't warp when being used with water-based inks. Shina is a Japanese variant (*Tilia japonica*) of a tree most commonly known as linden in English.

Medium-density fibreboard (MDF) gives a good flat surface and is relatively inexpensive if you want to work on a bigger scale. However, it will warp if it's not protected from the wet and it can blunt your cutting tools due to the resins that stick the fibres together. The alternatives include linoleum, which became available in the 1860s. This is made by layering linseed oil and pine resin on to a jute backing; when dry they oxidise at the surface, forming a rubbery texture. The beauty of linoleum is that it is made from renewable resources, and it is also much easier to cut than wood, making intricate designs more achievable. It can easily be mounted onto a wooden block to make it easier to handle when printing.

Cutting Tools

Cutting tools are probably going to be the most expensive part of your set-up. It is a good idea to think carefully about what you want to achieve before filling your shopping basket. I would recommend buying one of the entry-level kits from Essdee or Abig, or the Japanese carving tools all available from good arts and crafts stores, then experimenting with your first prints before investing in the best tools. You will quite quickly work out which tools you use most and then can head out and buy only what you need.

> **NOTE:** It is worth understanding that the blocks being carved for fabric printing are far less sophisticated than wood or lino blocks used for making prints on fine papers. One reason is that fine details are often lost on fabrics like linen and cotton; also the watery nature of the ink will not work with lines that are too fine.

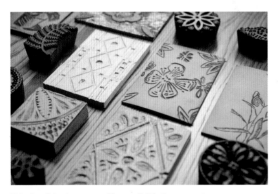

Printing blocks are readily available in many sizes and variations.

Cutting tools can vary in price and quality. Start with a mid-priced one like the Speedball set.

I have learnt the basic block-printing skills over time and absolutely love dipping into the technique when I want a creative couple of days experimenting with some design ideas on fabrics. I found out quite quickly that I only use four tools when carving blocks, mainly due to the simplicity of the designs for printing onto fabrics: two U-shaped tools (one large and one medium), a small V-shaped tool and the Japanese Hangito tool, which is a bit like a scalpel to cut with. I mainly only use the latter when working with wood, to cut the surface of the block around curved parts of the design to stop them splitting when cutting out.

Bench Hook

Another very important piece of kit is a bench hook. You could fashion yourself one or they are relatively cheap to buy. I am unable to work without one and I am sure this is the main reason I haven't had any finger or hand injuries as yet – or perhaps I haven't done enough carving!

Fabrics and Materials to be Printed

As long as the fabric is natural, I don't think there are any restrictions to what can be printed with a block. You may need to carry out some cloth preparations beforehand so that the dyes will adhere into the surface and be long-lasting (*see* Chapter 6).

If you are a beginner – or maybe you just can't wait to see how it might look – it is often a good idea to test print your block during the cutting process, just to check if it's going to look as you want it. It is handy to keep some scrap fabrics available for this process; they don't need to be prepared to take the natural dyes and can be washed and used again.

Printed test fabrics hanging in the studio are a good way to check your designs.

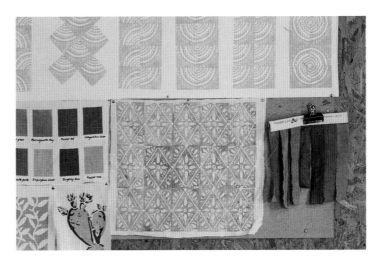

BLOCK PRINTING PROJECTS

My favourite starting point for pattern-making beginners is the potato, believe it or not! The potato is very easy to cut; a simple kitchen

Relief printing can be a really effective way to produce patterns, even with a simple potato.

knife or peeler can be used. Although you are limited with the amount of detail that can be obtained, it is a very inexpensive way to start. For designs that require more detail, which will take a lot of time to be cut, it makes more sense to use longer-lasting block materials like wood or linoleum.

While I encourage you to experiment with a potato to help you tie all the necessary components of this book together, I have included three projects below to take you through the techniques of producing different printing blocks. You will need to refer to Chapters 5, 6 and 7 to help make your dyes, prepare the cloth to print on and produce a design.

DIFFICULTY LEVEL: BEGINNER

Finished potato-printed wrapping paper.

There is nothing more satisfying than getting a stunning pattern to appear on a length of cloth using one dye colour and a potato – even better if the marks cut into the potato are really simple.

I would advise keeping your first designs basic, as it can be difficult to cut intricate

designs into a potato. This is mainly because you can't draw or easily mark the cutting lines on a wet potato, and when cut, it's difficult to see where you have been. As you experiment, you will either discover you have fantastic cutting skills or decide to move on to a more sophisticated block material, like wood or lino. You can use the simple design suggested here or cut your own repeating pattern.

In this project we will use paper as our medium, which is great for beginners as it doesn't need any pre- or post-treatments for the natural dye inks. You could even use a small tester pot of household water-based paints – this is a quick way to get started with the printing and can be a nice way of using up any leftover paint hanging around the garden shed.

- Large potato
- Dry clean cloth (paper towel or old tea towels)
- Small paring knife
- Chopping board/cutting mat
- Recycled paper with a non-shiny surface

- Thickened cornflour printing paste (Method 6.2) or water-based paint (Edward Bulmer paints are the most eco-friendly)
- Inking dish/plate
- Sponge (small make-up ones work well)

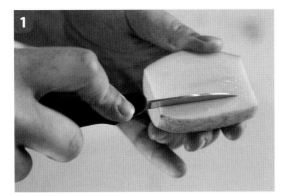

Cut the potato in half and dry the surface as much as possible with a cloth. Using the small paring knife, cut a straight line at an angle into the surface of the potato, to a depth of around 5mm (¼in) (aim to form three strips across the surface of the potato). Cutting a groove to remove the negative space is the easiest way to remove the unwanted surface. (You can use your own designs, but try to keep it simple.)

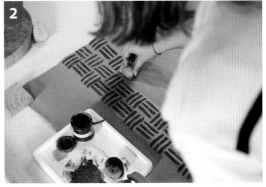

Set out the paper to be printed and weigh the corners down to hold it in place if you feel it is going to move while printing. Spoon a small amount of the block-printing paste (*see* Method 6.2) or any other water-based paint onto the inking dish. Dab one side of the sponge to ink it up, making sure the sponge is moist but not soaking.

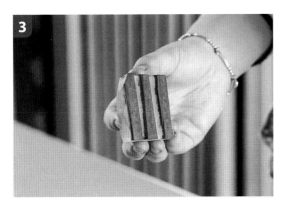

Sponge the ink onto the surface of the potato. This should be a gentle dabbing technique to avoid any splodges or excess ink going into the negative spaces. Experiment on a test piece of paper or cloth to see if enough ink has been applied and the effect you desire is being achieved. The potato surface will need re-inking after every print is made.

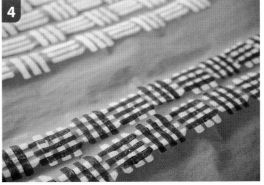

Once you feel confident, start the printing. Work in a methodical way, from left to right and from top to bottom. Turn the potato 90 degrees each time to give the pattern. If a chequered design is wanted, simply start again at the top, printing vertical lines over the horizontal and vice versa to form the checks. You could even print these lines in a different colour!

DIFFICULTY LEVEL: INTERMEDIATE

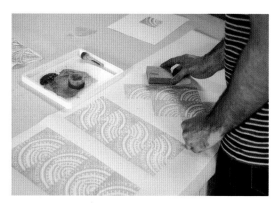

Experimenting with pattern using a square wood-mounted lino block.

EQUIPMENT AND MATERIALS

- Design on tracing paper
- Square lino, pre-mounted onto wood
- Pencils: 2B and 6B
- Permanent marker pen
- U-shaped and V-shaped cutting tools
- Bench hook
- Cloth
- Inking dish
- Small application sponge
- Scrap fabric for testing
- Recycled plain fabric or strong paper (wallpaper or cartridge)
- Thickened cornflour printing paste (Methods 6.2 for paper or 6.4 for fabric)

The aim of this project is to explore the different patterns that can be achieved by altering the angle of a square block when it is printed. The design needs to have only one line of symmetry for it to work best (*see* Design Project 7.2 to help you make your design).

Once the block has been cut, you can experiment with the pattern-making possibilities on an old piece of sheeting, or you can plough straight into a finished item. You should be able to get at least six different repeating patterns out of the same block. Have fun exploring!

I kept my design clean and simple to help with the printing process. Natural dye inks are quite watery so we need to think constructively about the design. I find it is better to have more positive space left behind, which will put more colour down.

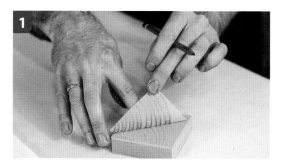

1 Mark your design onto the cutting side of the lino by rubbing through the tracing paper or by drawing freehand. Remember, the print will be the mirror image of your design cut on the block. Draw over the pencil lines with the permanent marker pen.

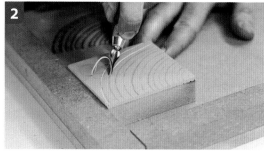

2 Use a fine V-shaped cutting tool to start marking around the shapes. Holding the tool into your hand and using your thumb and forefinger to guide it, cut at an angle into the space being removed. You can support and steady the blade while cutting with your other hand. Use the bench hook to stop the block slipping under the pressure.

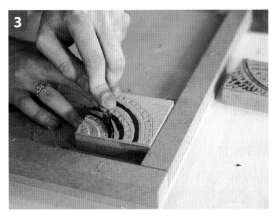

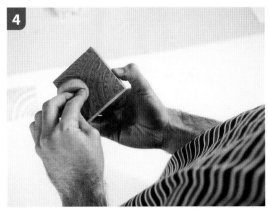

Once you have cut away around the most intricate shapes, you can use the wider U-and V-shaped tools to clear the areas of negative space (space not being printed). Again, using the bench hook to hold the block steady when carving, work from behind, making sure your fingers are never in front of the tool's blade.

When you have completed the cutting, do a test print. Rub the surface of the block with a clean cloth to remove all debris, then sponge ink onto the surface of the block and print onto similar fabric to that you intend to print on. You will be able to see if there are more areas that need to be removed or any lines that need tidying. Clean the block with a damp sponge.

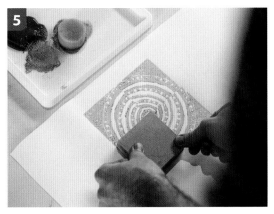

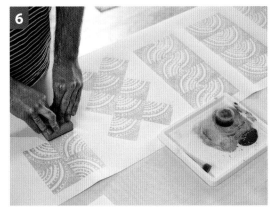

Set out the fabric or paper on the print table. It may need to be held in place if it is lightweight. Fabric can be ironed to help it lay flat. If the table covering is a coarse calico, friction will keep it in place. Using a sponge, apply the cornflour-thickened dye paste to the front of the lino block. Put the first print down, pushing firmly with the back of your hand. Re-ink the block between every print.

Begin exploring the different ways you can repeat the block. Print at least six blocks across by six blocks down to get the best idea of how it will look. Continue to use the space on your fabric or paper to make as many different repeating patterns as you can. You should find five easily.

DIFFICULTY LEVEL: ADVANCED

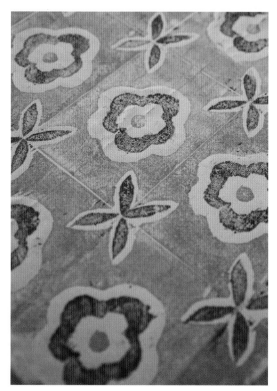

EQUIPMENT AND MATERIALS

- Design on tracing paper
- Two magnolia or plywood blocks (of the same size)
- Graphite pencil
- Permanent marker pen
- Japanese knife or Hangito tool
- Bench hook
- U- and V-shaped cutting tools
- Cloth
- Inking dish
- Small sponge to apply ink
- Two colours of print pastes made with a starch thickener (*see* Method 6.3)
- Linen or cotton napkins (upcycled are best)
- Pins or masking tape (optional)
- Muslin cloth for steaming
- Steaming pot
- pH-neutral soap
- Bucket for rinsing and washing
- Wooden spoon or tongs

Finished 'Flower Power' design on a napkin. Choosing bright contrasting colours to print the napkins was important for this design. The dye pastes were made from madder roots to give the red and marigold flowers for the yellow.

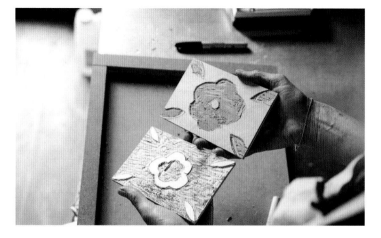

Carved blocks for the two-colour 'Flower Power' design.

Cutting a design into wood seems very complicated; however, with the right tools, it is relatively simple to do once you get the hang of it. In this project you will be using a specialist plywood block and some simple Japanese woodcutting tools. As with potato printing, simple designs that are easy to cut out often give the best and most pleasing results. (*See* Design Projects 7.4 and 7.5 for the design.)

You may have some tired readymade napkins that you would like to bring back to life or you can pick up some new ones – make sure they are 100 per cent linen (or cotton); no synthetic fibres. Equally, you can make your own. It is better to print before you hem, just in case you need to print right over the edge – the hem will interfere with the print as the block will not be able to lie flat and areas around the seam will not get printed properly. The best type of napkin to print is a linen one with a frayed edge, which can be done before or after printing.

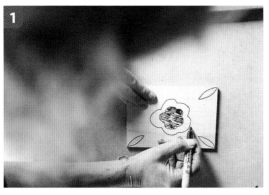

Trace each colour-separated component of your master design (*see* Projects 7.4 and 7.5) onto the separate blocks using a graphite pencil. Draw over the pencil with the permanent marker pen and shade in the areas you want to cut away. The centre lines should be marked to help with the registration.

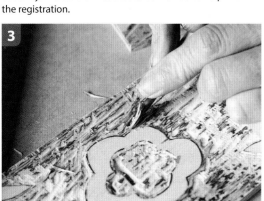

A Japanese knife or Hangito tool is a very good starting place if you want to achieve clean lines around your shapes. Use it like a knife to cut into the wood at a 45-degree angle around the shapes, angling it into the space being removed. Push the block against the bench hook and support with your other hand to control the cutting.

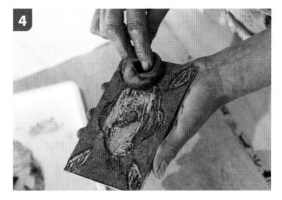

Use the U- and V-shaped tools to clear the areas of negative space (space not being printed). V-shaped tools will cut finer lines, so it might be best to start with these to clear up to the fine incision lines made by the Hangito tool. Keep using the bench hook to hold the block in place, making sure your fingers are never in front of the tool's blade.

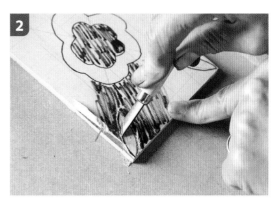

When you feel the block is complete, do a test print. Rub the surface of the block with a clean cloth to remove all debris, then sponge the ink onto the surface of the block and print on some similar fabric to what you intend to print on. You will be able to see if there are more areas that need to be removed or lines that need tidying. Clean the block with a damp sponge.

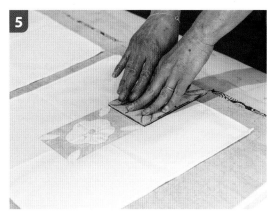

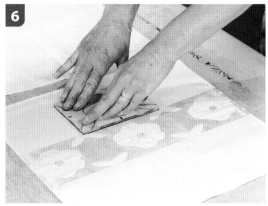

Set out as many napkins as you have room for. The calico table covering should stabilise them enough for printing, but use pins or masking tape otherwise. Put the first colour block down in the centre of the fabric. You can mark this with folds in your napkins, then use the centre lines on the back of the block to help register the position for the next prints.

Continue to print all over the napkin, working up and down from the central one until the first column is complete. When starting a new column, align the first print to sit next to the previous printed one to get a straight repeat.

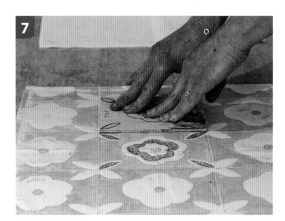

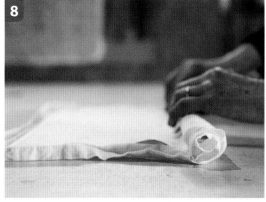

When the first colour is complete and dry, start the process again using the second coloured ink. When all of the napkins have been printed with both colours, allow the napkins to dry thoroughly.

Roll the napkins in muslin and place them in the steamer for 30 minutes to an hour. When steamed, the prints can be washed straight away or left overnight. Rinse and wash thoroughly with warm water and a pH-neutral soap. The gum thickener should rinse out with a bit of gentle rubbing.

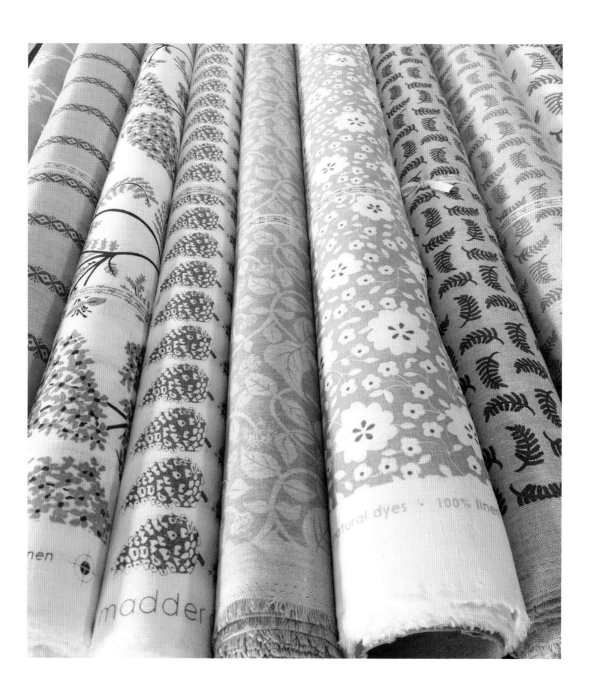

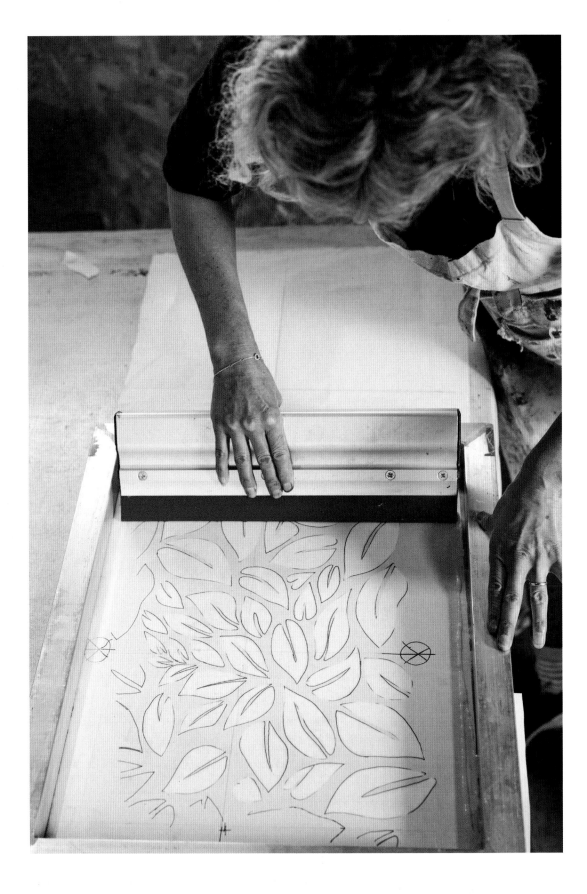

SCREEN PRINTING

I completed my first screen prints at school in the 1970s and had thought then it was a relatively new invention, started by the pop artists of the 1960s. However, the first proper evidence of screen-printing practice was actually from China around the period of the Song dynasty (AD960–1279) and it has even been suggested that this method of pushing paint through a mesh was used for cave paintings in prehistoric times. The technique developed from China to neighbouring Asian countries; in Japan, human hair was used for the screen mesh and a stiff bristle brush as a tool to push the paint through. Later, the hair was switched for silk, hence the name 'silk screen printing' originated.

Screen printing as a process arrived into Western Europe in the mid-eighteenth century, presumably brought by the shipping merchants trading along the Silk Road. The process seemed to be more commonplace in textile printing, and it was around this time that the rubber-bladed squeegee originated.

Photo-imaged stencils were introduced in the early 1900s, which revolutionised commercial screen printing. The technique lends itself well to printing on a variety of different materials and surfaces.

In the late 1930s the screen-printing technique was adopted by a group of New York artists who used it to make their art on paper. To differentiate themselves from the textile commercial side of the process, they derived the name 'serigraph' (from the Latin *seri-* meaning silk and the Greek *-graphein* meaning to draw) to describe the technique.

And finally to the screen prints of Andy Warhol in the 1960s, such as *Marilyn Diptych* and *Campbell's Soup Cans* which influenced me so much as a young artist.

Full-size textile screen for printing fabric by the metre on a large flatbed table.

Lara of Ink & Spindle, when asked to choose her favourite design, said it was like choosing a favourite child. But currently it is the *Riverbend* design with its timeless mid-century vibes and giant 1m (39in) repeat.

Ink & Spindle

Today I continue to be inspired by fellow textile screen-print designers who oversee the whole production process in house. Lara Cameron and Caitlin Klooger established Ink & Spindle in 2008. Their beautiful fabrics are all inspired by the flora and fauna of the Australian landscape.

Having their studio in a dormitory of an old convent in Abbotsford, Melbourne, is perfect for their long print table of 13m (14yd). Lara was originally a graphic designer, but was fascinated by textiles from childhood. Once she discovered screen printing as a technique, the possibilities blew her mind:

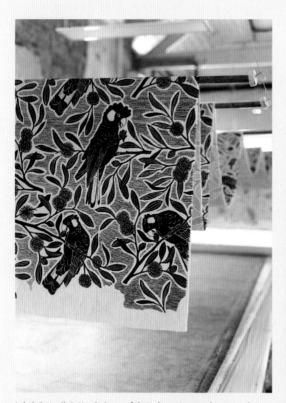

Ink & Spindle's Kookaburra fabric, hanging to dry over the print table.

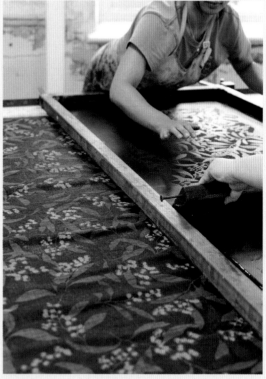

Hand printing in progress at the Ink & Spindle studio in Melbourne.

I love that it harnesses a mix of creative and technical skills. As soon as I learnt about how I could translate my digital images onto silk screen, I was hooked. I love that I can create an initial design through a variety of mediums (photographic, hand drawn, painted, lino printed, etc.) then have the ability to edit and perfect them in Photoshop or Illustrator before exposing them onto screen. And I love that the magic doesn't end there – there's endless possibilities for how to print that artwork, experimenting with different colour ways and base cloths, and *then* we get to create a range of beautiful products. The fun never ends.

Lara is spot on with her approach to the design process:

Embrace the limitations! One of the best things about screen printing is that it forces you to think within relatively narrow constraints (compared to digital) but that can give birth to some really great ideas. Transparent inks can overprint to make beautiful additional colours, blotch prints can turn plain base cloths into colourful ones and integrating texture and detail into your design allows you to design prints that work well both as a large-scale object like a curtain but also when cropped down into a cushion or lampshade.

Jennie Jackson

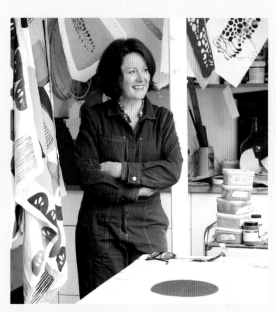

Jennie Jackson with her fabrics.

Jennie Jackson has a more contemporary approach to her work, evoking moods from free-flowing lines and colours. Her inspiration comes from her experiences:

Like visiting a favourite coffee shop in West London with friends and trying to capture a romantic, bohemian atmosphere – I love that, historically, art and politics and music have always swirled together in coffee shops. Or growing sunflowers with my daughter when she was little, or a trip to mangrove swamps in Sri Lanka, or things that have always interested me, like mudlarking or the story of Ada Lovelace. All these are seeds that then turn into sketches in my sketchbook and ideas about colour.

Most of Jennie's designs are produced by individually made paper-cut stencils. She fell in love with this technique because of the freedom involved in the making process: 'This way you are using the craft knife like a pencil; the line flows freely, and you have to be positive.'

Jennie Jackson's favourite and enduring design is *Troubadour*:

It was one of the hardest to get right, although it appears quite simple. I had so many versions before I settled on the design, and it has evolved over the years to be a bit simpler than when I started. This is the coffee shop design and I love that it's about friends and the whole counterculture that grew up in these spaces in the fifties and sixties. And, of course, it references the mid-century feel my work has.

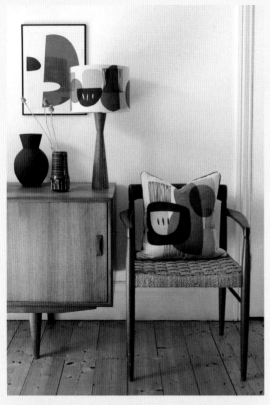

Jennie Jackson's *Troubadour* design on a lampshade and a cushion.

Natalie Gerber

Natalie Gerber is a surface pattern designer based in Calgary, Canada. She has successfully grown her small-scale textile-printing studio to produce textile collections and provide design and silk screen-printing services for specialised projects. She runs her own and guest-artist's workshops.

My work is inspired by timeless, functional design for everyday living. In particular, I am influenced by the decorative movements (and tenacious women) of the first half of the twentieth century such as Lucienne Day, Phyllis Barron and Dorothy Larcher. My work aims to find a balance between crisp lines, organic shapes and textures.

My process always begins with an idea or vision of a pattern I'd like to explore and is often inspired by something I've observed – sometimes as mundane as the grasses I see on my daily walk, or an interesting mark that I've noticed being repeated in my sketch book. I am also inspired by exhibitions I've visited or even a book that I've read. Referencing collected images and working from life, I carve, draw, paint and make marks. The outcome of these explorations are then used to digitally engineer repeating patterns that playfully investigate scale and are then transferred to screens and hand printed onto yardage for linens, bedding, soft furnishings and interiors.

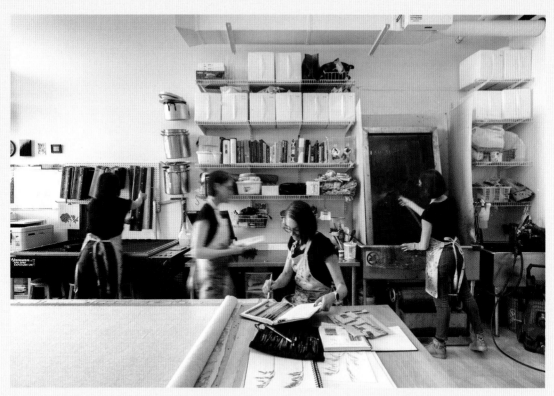
Natalie Gerber in her studio in Calgary.

Like most designers, Natalie doesn't like to choose a favourite design, but when pushed on the matter she chose her *Peoniez* pattern from the 'FLORALZ' series.

> This repeat was inspired by the favourite flower of a friend who passed in 2017 from cancer. I originally designed the pattern as a three colour repeat, and it has proved to be a favourite with my clients. Every time the studio custom prints this pattern we will get requests for colourways that I have never considered, and so it continues to keep me excited! We've printed it with a split fountain background, reversed the background and printed it with four colours, from elegant monochromatic colourways to the brightest of brights – it continues to inspire and surprise me!

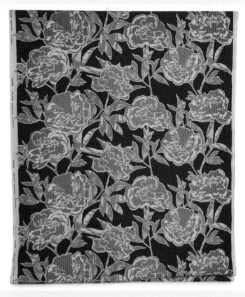
Natalie's favourite *Peoniez* fabric design.

GETTING STARTED

Equipment

It may seem like a lot of expensive equipment is required for screen printing and I think this can put a lot of people off experimenting with the process. Like most crafts, the investment you make will all depend on what you want to achieve. All you really need to get started are two essential pieces: a screen and a squeegee. Both are relatively cheap and easy to buy these days. I would definitely recommend getting an aluminium-framed screen as the cheaper wooden ones are prone to warp with frequent washing.

The process does start to get expensive if you want to get into stencilling your screen with photographic emulsions to give a more permanent finish. However, I would only recommend this if you intend to reuse the design many times. There are quite a few systems available for stencilling screens with a photographic emulsion these days; it is even possible to get mesh sheets ready to be exposed with your image at home, negating the need for a screen at all.

Photographic emulsion is a chemical and a lot can be wasted when washing away unexposed areas and cleaning equipment, so if you are keen to keep your chemical footprint and drain water as clean as possible, I urge you to master the paper stencil technique. Not only does this method allow you freedom to explore with your methods and designs, it's also a very sustainable option – especially if you choose to use recycled newsprint as your stencil paper.

Screens

Screens come with different mesh counts and although we will tend to just use a standard one for our projects, it's worth explaining what they are and what they mean. Generally, the finer the mesh count, the finer the detail that can be achieved with printing. It would be preferable to use higher mesh counts when printing onto paper or fabrics like fine cotton and silk, but it is also necessary to consider the inks you will use and how the design will be stencilled.

In the UK a T measurement system is used to describe the mesh, and the count is given as how many threads there are per centimetre. American measurements are given as threads per inch, so the numbers will be larger. For example, the standard screen I would recommend is UK 43T, which is a US mesh count of 110. These days, the mesh is generally made from a high-quality polyester monofilament.

The size of screen you choose to start with may be dependent on your space available but also on what sort of things you are planning to print. If you are decorating small items with small motif designs, an 'A4' size should be sufficient. (We say the screen is A4 because it allows us to print an area that is A4 size; the actual dimensions of the screen are slightly larger than A4 to allow space for the ink and the squeegee to pass over the design.) The squeegee needs to fit inside these dimensions, and most stockists and speciality stores will quote this information so you can buy a squeegee that suits your screen.

Squeegees

Squeegees are a very important buy. Generally you will buy one that suits your screen size and I advise getting the best one you can afford as they tend to last forever and shouldn't need replacing.

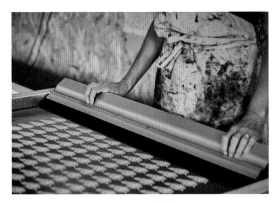
Large textile screen being prepared for printing.

The aluminium handle option gives more flexibility as the blades can be replaced with this system. The blades tend to be made of natural rubber, neoprene or polyurethane – the latter being the most resistant to damage and the most popular nowadays.

Next, we need to consider the hardness and profile of the rubber, which are quite extensive and particular to the printing process. A general rule of thumb is: the harder the blade, the less ink is pushed through the mesh. These days most manufacturers colour code the rubbers into soft, medium and hard, so we don't need to get bogged down with numbers. The profile of the squeegee is the same shape as the edge of the blade and there is quite a choice. The profile is also important for determining the thickness of ink that is laid down, how the printing is carried out and what substrate is being printed.

While the square blade squeegee is most common, I would only recommend this to be used for finer fabrics and paper. For most textile printing, the best blade is the rounded or bullnose profile, and it will suit the inks you will make with natural dyes. So, if you know you are going to print only textiles like linen, go for one squeegee with a bullnose profile – you can always get a square-bladed one later.

Stencilling

This is the name given to making the image ready to print. It is done by removing the area from the stencil substrate that will make the image. In the first projects below, the focus is on using a simple stencil cut from newsprint paper. Newsprint is the preferred choice to other papers as it is fine enough not to leave an ink edge on the cut areas, which can collect the ink and affect the clean edges we want to achieve when screen printing.

Registration

This is quite crucial if you are aiming to do print runs for production of more than one item or you are printing in more than one colour. A

Newsprint paper stencil, cut ready to print.

Washing area made for cleaning larger screens outside.

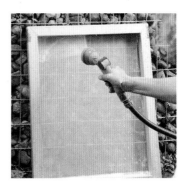

hinged press may be a good investment if this is the case. They are also very easy to make using specialist butterfly hinges, which are readily available. Alternatively, registration marks can be achieved easily with masking tape or a fabric marker pen.

Washing Out Facilities

Ink should not be allowed to dry in the screen, so the screens will need thorough washing and drying in between printing. For smaller screens, your workshop sink may be large enough for you to clean up sufficiently, but for larger screens an outside area could be designated for the job.

I use a hosepipe with a spray attachment. The spray needs to be powerful enough to remove all traces of inks and binders from the mesh. You can position this area near an outside drain or work on some free-draining land. I love printing on sunny days so I can dry my screens in the sun.

SCREEN PRINTING PROJECTS

Project 3.1: Printing a Background Colour Using Cut Paper Shapes (Negative Space Printing)

DIFFICULTY LEVEL: INTERMEDIATE

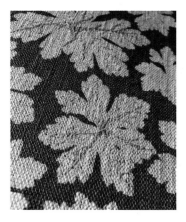

Background printed by placing leaves under a screen.

- Design to a size that fits one of your screens (*see* Design Project 7.3)
- Newsprint paper
- Craft knife
- Screen (43T)
- Squeegee (bullnose profile/medium) to suit the size to be printed
- Fabric to be printed
- Spatula
- Mordanted printing paste in any colour (*see* Method 6.3)
- Hairdryer or iron (optional)
- Muslin cloth
- Steam bath
- Screen-masking tape/brown paper tape

The outcome of this project is a piece of fabric that has the background colour printed with shapes forming the unprinted areas. I also like doing this with some shapely leaves from the garden; the leaves have to be quite thin for it to work well, but it is good fun and I urge you to have a go. You may well then start to find lots of other suitable things that you could use as a resist to form your shapes. I like to keep the prints small using this method, especially if you have a lot of negative space surrounding the shapes. The more space you have, the more ink will be required, so it is important to bear this in mind.

A border is needed to finish the printed area around the shapes. Allow space inside the screen to form an inkwell (the ink needs to clear the image at the top and bottom of the screen when printing). The design you use could be quite freely done if you like to be experimental, or if you feel less confident about how it will look, spend some time making a design. The work of Henri Matisse and some of Picasso's artwork can be a good inspiration for this technique.

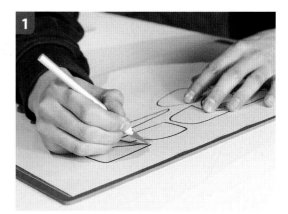

If you have a prepared design, trace it onto newsprint paper and cut out the components using a craft knife. You will need a border around the design, so choose a screen that allows for this and fits your design comfortably with room for an inkwell and for the squeegee to pass fully over the design on both sides. (Remember, the more negative space is visible, the more ink will be required.)

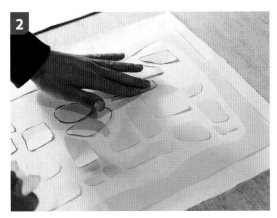

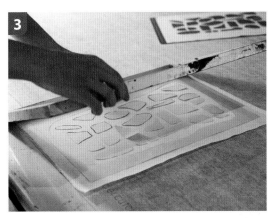

Lay out the fabric to be printed. This should be selected according to your desired end use. If you want to print more than one piece, set out more fabric, allowing enough space between each piece so as not to be putting the screen back over freshly printed pieces. You can work out the position the screen needs to be in relation to the fabric beforehand by marking the centre lines on the stencil and fabric to be printed.

Place the cut shapes as per your design onto the fabric. They will not need sticking, as they will be held in place once you put the screen down. It is a good idea not to have too many small pieces that could move while you are setting out. Remember, for paper stencils, simplicity is best. When you are happy with the layout, lower the screen carefully so you do not to move or dislodge any of the pieces.

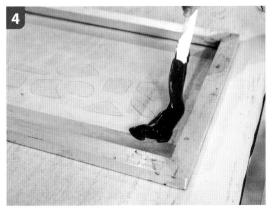

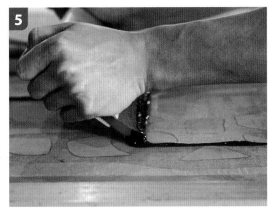

We are now ready to print. Use the spatula to load the inkwell with plenty of ink; it's always better to have more than is required. You may need someone to hold your screen to stabilise it as you use both hands on the squeegee.

Place the squeegee so it will take all of the ink over all of the design and repeat to bring the ink back, firmly and cleanly. A 45-degree angle works well with a bullnose or rounded squeegee.

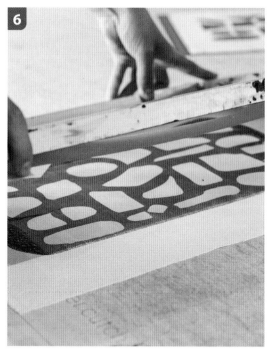

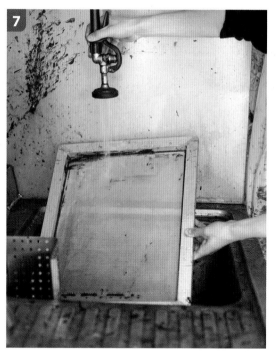

Rest the squeegee in the screen and slowly lift it from one side, clear of the print. If you want to do more prints, you should be able to place the screen down and repeat, making sure to load with more ink if it has depleted by more than half. The stencil will stick to the underside of the screen after the first print and so can be repositioned.

The stencil paper absorbs moisture and will begin to get wet and misshapen or crinkle, so you will need to judge when it is time to stop the print run. The excess ink should be cleaned from the screen and added back to the ink pot before removing and disposing of the spent stencil. The screen and squeegee should be washed thoroughly using a powerful water spray.

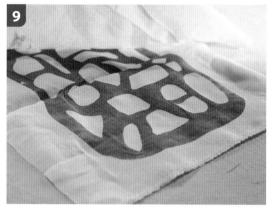

The printed fabric should be left to dry thoroughly; a hairdryer or iron could be used to make sure. Roll up the fabric pieces separately in a muslin cloth, making sure the print faces outwards.

Set in the steam bath for an hour, then carefully unwrap and wash in warm soapy water to remove any thickener.

DIFFICULTY LEVEL: ADVANCED

Mordant printing is an old traditional process whereby a pattern is printed onto fabric with a thickened mordant (*see* Method 6.5 in Chapter 6). The fabric can be dyed in a heated dye bath using any adjective dye (a substantive dye can be used but the unmordanted fabric will take up some of the dye colour too). The colour will form permanently only where the mordant has been printed. This is a lovely technique to experiment with as it's not until the final wash that you will see the results. The aluminium mordant paste will benefit from a small addition of a dye extract, so you can see where you have been printing.

Design Project 7.5 explains how to make a repeating design for this project. We will use a paper stencil and aim to keep our design relatively simple. If you are keen to pursue printing larger pieces of fabric, you may need to think about what size of screen you will purchase – a bigger screen will cover a larger area in one go, which will minimise the number of times you need to move and register the repeating unit to cover all of the fabric. A screen with an A3 printing area – as used in this project – is a good idea and larger sheets of newsprint will also be necessary. However, there is nothing to stop you being successful with a smaller A4-size screen; it will just need more time, patience and a few more cut stencils.

The key to success is working methodically, making a printing plan, marking out the fabric for registration and using a hairdryer to dry between printing. You will need to have more than one of the same stencil so that the print run can be broken while the printed areas dry, before filling in the gaps.

EQUIPMENT AND MATERIALS

- Metal ruler
- Drawing of the design to scale
- Newsprint paper (A3)
- Fabric to be printed
- Fabric marker pen
- Light box
- Cutting mat
- Scissors
- Scalpel blade: 11 or 10A
- Masking tape or pins
- Screen, larger than design area
- Spatula
- Mordant printing paste (*see* Method 6.5)
- Squeegee to fit the screen
- Hairdryer
- Calcium carbonate neutralising solution
- Wooden spoon
- Dye bath
- pH-neutral soap

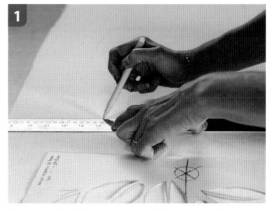

Measure to find the centre point of the design and use a fabric marker pen to mark this on the fabric being printed.

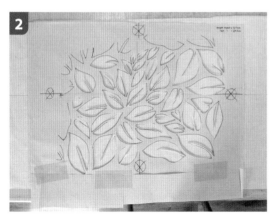

Trace the repeating unit of your design onto a sheet of newsprint paper that is slightly larger than the screen you will be using. The light box is a good idea to help you trace the design accurately. To save cutting time, it is possible to cut through several sheets at a time. So, layer about two or three more sheets under the marked one and carefully cut the design through all layers to give you more stencils. On each stencil, mark the edges of the next repeat and the centre lines.

Lay out the fabric on the print table; if your table is not big enough to take all of the fabric in one go, set it out to maximise the number of repeats to be printed each time. Pin or tape the fabric down so it doesn't move while you are printing. Using the fabric marker pen and a metal ruler, draw on the horizontal and vertical centre lines. The measurement between the centre lines is the measurement of the repeating unit. (Measure from the same point across the design to get this number.)

Print one row at a time and every other block in each row. This is necessary so you don't put the screen down on the previous print. Place the stencil down onto the first area to be printed so it matches the centre lines marked on the fabric. Position the screen over the design as centrally as possible and make sure the boundaries of the newsprint cover any gaps in the mesh.

Use a spatula to fill the ink well at the end of the screen with the mordant paste. Print, passing the squeegee over the design enough times to give a good covering of the paste onto the fabric. When you have done the first prints in the row, clean the paste from the screen, remove the stencil and wash out the screen. Dry the mordant-printed fabric on the table with a hairdryer.

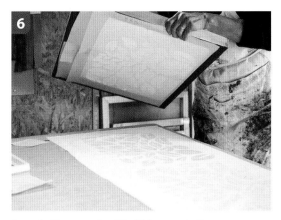

Repeat with a new stencil to fill the gaps in the row. Continue to print in this way until the fabric is covered with the design. (A small amount of dye extract can be added to the paste so you can see more clearly where you have printed.) Allow it to air dry or use a hairdryer – the vinegar smell of the paste should be less noticeable as it dries and evaporates away.

Before dyeing the mordant-printed fabric, it is important to make sure any traces of vinegar and gum thickener are removed from the cloth. Submerge the dried cloth in the solution of calcium carbonate for around 20 minutes, stirring occasionally with a wooden spoon. The fabric should be rinsed in warm water to remove all of the thickening paste before dyeing.

If using fresh or dried dye plant fibres, you can prepare the dye bath solution ahead of time by gently simmering the chopped-up fibres in water for about an hour. The fibres can be removed or left in the pot when dyeing the cloth. The temperature should be kept below a simmering point when dyeing with most plant dyes to achieve good colours. (*See* Method 6.6 in Chapter 6.)

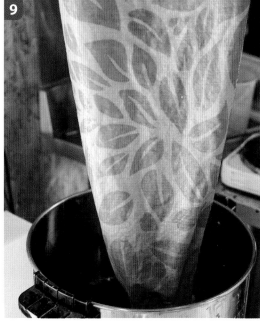

Add the rinsed printed cloth to the dye bath and simmer very gently. It is important to stir frequently to avoid uneven take-up of the colour. The cloth can be left to cool overnight in the pot. When cool, remove the fabric from the dye pot, rinse and wash the cloth in hand-hot water and use a pH-neutral soap. The cloth can be boiled or left in the sun to remove any colour take-up in the unmordanted areas.

ECO PRINTING

The term eco printing is used to describe the work of textile artists using plants directly to achieve colour prints on paper and fabrics. First introduced and written about by India Flint 25 years ago, eco printing was developed to be a sustainable and eco-friendly way of using colour from the nature that surrounds us, only using raw materials that are readily available so as not to leave a footprint on the world.

I am sure these methods and similar nature-printing techniques are thousands of years old, despite the first evidence being only medieval in origin. Roderick Cave's book, *Impressions of Nature: A history of nature printing*, delves into the origins of the practice and I recommend reading it if the history interests you. These first evidenced prints were used to help collect information about medicinal plants in a catalogue form.

The first found written instructions for a nature-printing process were in 1853 by an Austrian Printer from Vienna called Alois Auer, in *The Discovery of the Natural Printing Process: an Invention*. The technique involved making the impression of the plant material in a sheet of lead – this soft metal is easily marked. The indentations would be inked, and prints taken from it. This later evolved into a large and serious scientific process.

Impressions of Leaves by Pierre Joseph Hubert Cuypers, 1837–1921 (Rijksmuseum collection).

Japanese fishermen were using a printing technique called 'Gyotaku' in the mid 1800s to make a record of the fish they caught; whether this was for catalogue purposes, to show customers their catch or maybe even just to brag! Essentially, the technique involved painting the fish with cuttlefish ink, which meant the fish would still be edible, then taking off a print by rubbing over rice paper. 'Gyotaku' comes from the Japanese 'gyo-' meaning fish and '-taku' meaning stone impression.

Nature printing is very much still a practised art and there is even a society that can be joined: the Nature Printing Society. To me, eco printing means experiment and wonder; nothing can go wrong, the results you achieve will be all magnificent and your prints will have a look that tells the story of how you carried out the process.

Leaves being set out onto mordanted hemp-silk fabric, ready for bundle dyeing.

If you choose to experiment a lot, it is a good idea to make notes and keep records so you may tweak and play more and marvel at the results each time. The results you achieve will depend on many factors (plant season, time left to process, parts of the plant being used, water quality and pH, mordants and type of fibre being printed). Notes are essential if you want to get close to reproducing any of the prints, but also, like the early nature printers, it is a way of cataloguing the colours and forms that you have foraged and found locally to you.

FEATURED BOTANICAL PRINT ARTIST

Elisabeth Viguie-Culshaw (@bettysbeautifullife)

Elisabeth Viguie-Culshaw is a botanical printing artist and mentor, sharing her art and techniques in person and online around the world. With a studio in her Victorian kitchen basement, she is surrounded by parks in Glasgow where she can source much of her material in a sustainable way. Seasonality is a big part of her work, making use of the variations in the leaves from spring to autumn.

The botanics around me keep me on my toes as every season or new location bring in different challenges. I have to be up to date with chemistry and natural dye processes, but what I love is how it connects me with a time, place and people. I recently curated an exhibition of my work and I described the pieces 'botanical moments' – those are pieces created in a specific time and place. They will forever remind me of that special moment spent with a group or an individual.

Elisabeth started 'The True Colour of the Cotinus' project during the recent pandemic. It involved creating botanical prints using Cotinus leaves only.

I spent days printing it on fabric, paper, extracting pigment, tannin and so on... with a group of about 700 online participants from all over the world. I loved testing the same process day in and day out. It was very reassuring and became my meditation. When the world goes crazy, I print some Cotinus in my studio and I feel safe because I am in control of that process at least.

Her top tip to newcomers is to slow down and observe: 'Observe and test, test and record. Remember you learned to walk before you learned to run.'

Betty's teak leaf prints.

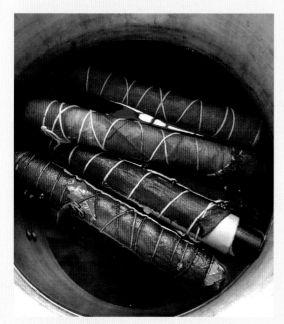

Betty's wood bundles.

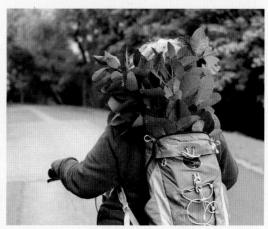

Betty foraging for Cotinus.

GETTING STARTED

It is important to be conscious about working sustainably and continue to strive for a zero-waste policy. Eco dyeing was born with this totally in mind and I hope the following projects reflect this. In our current world situation, we must consider the impact of our work at all times and aim to recycle, repurpose and compost any waste we produce.

So, We Are Going to Use Plants? But What Plants and Where From?

Ethel M. Mairet; Jenny Dean; my local dye plant horticulturists, Ashley and Susan of Nature's Rainbow; and many other reference books have all provided me with an expanse of knowledge and dye plant information that has helped complete this book. While I have still gone about picking leaves and flowers from just about everything growing in mine and my friends' gardens over the years to test, the wise and much more practised methods of others have consistently produced better and more reliable results.

In Chapter 5 we explore in more detail the dye plants I prefer to use for printing on fabrics,

Leaves that have been dried will need refreshing in hot water to make them supple to layer for printing.

and how to use them as printing pastes is covered in Chapter 6. In this chapter we are aiming to explore plants from our local area and to use the best and safest practice when handling any plant materials. I have listed below some common and easy-to-source plants in and around the UK that will be a good starting point

Colours can be extracted from the roots, bark, leaves (fresh and dried) and flowers of many plants. It will be easier to use less bulky plant materials that can be flattened into layers for the following eco printing projects, so mainly leaves and flowers (but the barks, roots and stems could be used to make up dye baths). Collect when the plants are fresh and hang to dry for winter projects.

> **NOTE:** Please think about safety when handling plant material. So many lovely ones growing in our gardens can cause allergic reactions because they contain toxins. The RHS gives a very good list and overview of these (www.rhs.org.uk/prevention-protection/potentially-harmful-garden-plants) and I urge you to double check any plants you are not sure about before you start handling them.

Wild foraging is an exciting playground that opens up so many more possibilities. Abigail Booth is an expert in this area and in her book, *The Wild Dyer*, she lists her favourites as oak galls, acorns, alder cones, blackberries, elderberries, rosehips, nettles, dock and bracken. You must remember to be respectful to the environment, picking only what you need from abundantly growing plants. Also be careful to collect only what you know not to be poisonous.

I have carefully chosen three of my favourite projects for this chapter. Not only do they tick the boxes for eco credentials, but they also cover many of the skills you will need to be a master eco printer. I also urge you to delve further and wider when you are experimenting and having fun.

ECO PRINTING PROJECTS

Project 4.1: Bundle Dyeing to Make a Leafy Lot of Patchwork Pieces and Repurpose Fabrics

DIFFICULTY LEVEL: BEGINNER

The hemp-silk patches have taken up the colours from the leaves and once washed and dried can be stored or made up in a patchwork project.

EQUIPMENT AND MATERIALS

- Collected plant material or dried leaves (*see* Table 1, Chapter 7)
- Mordant-prepared scrap fabric pieces (*see* Methods 6.8 or 6.9 in Chapter 6)
- Rainwater in a spray bottle
- Wax paper (recycled wrapping) or greaseproof paper
- Cardboard tubing or piece of dowelling
- String or lengths of rag fabrics
- Steam pot (large pan that will work with a metal colander or chicken wire fitting)
- Hotplate or stove top

This is one of my favourite methods; it is not only a very simple way of nature printing but is also quite possibly the most eco-friendly, depending on whether you steam or leave your bundle wrapped and in the sun. It does not require much water, dye plant material or energy. To me, this is the most fun method to experiment with different plant materials too, as you can quickly see if they will lead to interesting colours by how they imprint on the cloth you are using.

I have split this bundle-dyeing method into two parts. The steaming method is faster and you will quickly see how the plant material collected will behave. The solar method will take longer as it is relying on the sun to generate the heat.

While making ourselves some lovely printed patchwork pieces, we are also starting record keeping about the plants we have collected and where they are from. I find it best to keep a photographic record, as I never want to store away my prints when I can patch them together or use them as gifts.

I always keep my fabric offcuts, whether they are from the selvedge (my curtain maker always returns offcuts, however small, in nicely tied packages), from pattern cutting when we make our products, or from misprints that have occurred on a bad printing day. The type of fabric you choose may or may not need a pretreatment (*see* Chapter 6).

Steaming Method

This method will speed up the wait – and it is waiting that seems to give us the most colourful prints – so even after you have done the steaming, leaving the parcel a few more days will really enhance the results. Because the fabric pieces are quite small, this method works well if you make several small bundles that can all fit in the steam pot individually. It will allow the steam to penetrate through better and even speed up the steam time – something else that can be experimented with.

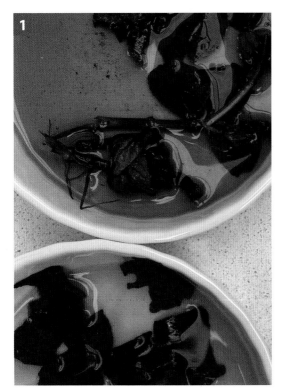

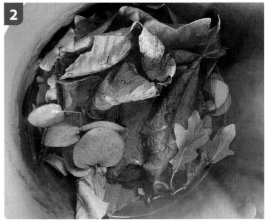

Sort through your collected leaves. Put them in a bowl and cover with tepid water for a good 30 minutes; you want to make them supple enough to roll up in the fabric pieces. If using dried leaves, they may be best left to soften in the water overnight.

It is a good idea to test your collected materials for potential dye-yielding colour by carrying out the seep test. Add boiling water to a small amount of plant material in a white bowl. Leave it for 10 minutes. If it seeps colour, it could be a good eco printing possibility.

Set out the pieces of mordanted fabrics, dampening them with the rainwater in a spray bottle if they are not freshly rinsed from out of the mordant pot. Place the leaves on the fabric pieces, arranging them grouped in species or in a pattern to your liking. You need to work out how many you can fit in the steamer in one go and just do them in batches.

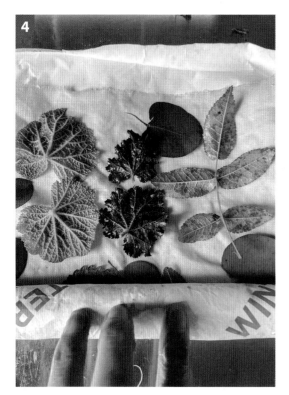

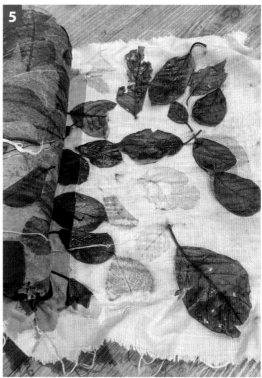

It is nice to see individual leaves in the prints, so it's best to roll up each bundle on its own using a recycled wax or greaseproof paper to prevent seeping through the overlapping cloth. Roll them up very tightly onto a cardboard tube or piece of dowelling. Tie together by overlapping tightly with string or strips of rags.

Once you have made enough bundles to fit into one layer of the steam pot, put on a tight-fitting lid to conserve as much energy as possible and steam for 30 minutes to an hour. Check frequently that there is sufficient water in the base of the pot and top it up when it is getting low. Check the bundles after 30 minutes for signs of colour seeping through the layers. Turn off the heat and allow to cool before removing.

The bundles could be left for a day or so to develop further – or, if you can't wait, unwrapped and hung out to dry – allowing the leaves to fall off in their own time. The lovely botanically printed fabric can be wrapped in tissue and stored until needed or sewn into a patchwork for a project or to make a gift. (I prefer to do the sewing before giving a final wash so the edges of the fabric will not fray too much.)

Solar Dyeing Method

This is a slow version of the above. It requires the same steps, but instead of a steam pot, you will need a container for the damp bundles. We will be leaving them in this for a few weeks – even months if you are very patient or forget! Warmth or heat speed up all chemical reactions, so if it is summer a sunny spot will help with the transfer of colour. If you are leaving them for longer periods, it may be a good idea to check from time to time on their progress and that they are not drying out. If they appear dry they can be sprayed with the rainwater solution, but if they are looking a bit mouldy, spray with a weak vinegar solution.

Method

Follow the steps for the Steaming Method above, but at step 4, roll all of the fabric pieces up together without the wax paper and dowelling. Pack as tightly as possible into the glass jar or a container with a sealable lid and leave in a warm place in the sun. Protect with a dark cover if in a glass jar and in direct light. Burying in a compost heap works well too apparently, but keep them in the container if you are going to try this! The effect you will achieve will be different to the separated leaves in the steaming method as the colours will seep into each other and each layer as they develop over time.

- Sealable container, preferably a large jam jar (like a sweet or pickle) or a big yogurt pot with a snap lid

Bundle of prepared cloth, tightly packed into a jar that can be left in a warm, sunny place.

DIFFICULTY LEVEL: ADVANCED

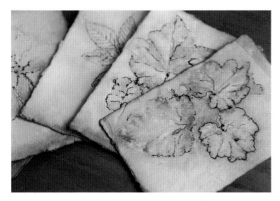

Finished printed papers that have been doodled with a fineliner pen.

- Natural tannin mordant from oak acorns or sumac leaves (*see* Method 6.9)
- Khadi paper (can be purchased in many sizes)
- Dried and fresh plant leaves and flower petals
- Wooden or metal sheets for clamping the paper layers together
- String, bulldog clips or elastic bands
- Steamer (optional)
- Large soft-bristled paintbrush
- Dye pot
- Dye colour (optional)
- Black fineliner and coloured drawing inks (optional)

The aim of this project is not to get an overall image of the plant part being used but to extract the colours from it to give an impression of where it has been. This may be pretty enough to leave as it is, or if, like me, you try to find patterns and imagery in your print, take a fineliner pen and draw away, highlighting components of the print to give it some depth.

Petals and whole flowers of Coreopsis are used in this paper bundle print.

Prepare the tannin mordant by boiling 25g (1oz) of acorns or any tannin-rich plant materials in 1 litre (1¾ pints) of water for an hour. Soak the papers in the cooling liquid for 12 hours or more. Don't move the paper around too much as you don't want to damage it; the khadi papers are quite strong. Once soaked, remove from the tannin solution carefully and set out ready to make the plant sandwich.

Seep fresh plant material in warm water to make it supple. If using dried plant materials, seep in hot water and leave overnight. Start to assemble your paper prints, layering the plant material on one sheet and placing the next sheet on top and so on, until every piece of paper has been covered and is in a stack.

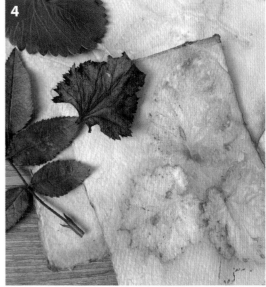

Sandwich the stack between the metal or wooden sheets and fasten them together using string, a bulldog clip or an elastic band. Place the clamped sandwich stack back in the tannin pot or in a steamer; alternatively make a dye bath from other dye plant material like madder. Gently simmer in the pot for an hour and then leave to cool in the liquid.

Carefully remove and unpick the sandwich to reveal the results, leaving the plant material to dry on the paper before brushing it off with a large, soft-bristled paintbrush. Once the prints are dry, and if you want to embellish them further, experiment away with a black fineliner or other coloured drawing inks.

DIFFICULTY LEVEL: BEGINNER

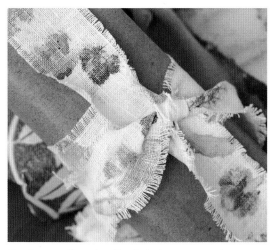

Fine linen or silk work well with the hapazome technique and makes a beautiful addition to any wrapped gift.

EQUIPMENT AND MATERIALS

- Silk ribbons – old recycled ones are best or some mixed fabric lengths like hemp silk
- Fresh plant material
- Folded piece of card
- Flat stone or end grain wooden board, like a butcher's block
- Metal hammer – medium-sized with a flat, smooth surface
- Rags and scrap newspapers to protect the silk cloth from too much abrasion
- Steam pot or steam iron
- Muslin cloth for steaming

Perhaps one of the fastest and most satisfying methods of printing I have done, there is something quite pleasurable about yielding a hammer – although I will just point out that this method works best when the hammering is done quite gently! Hapazome is a Japanese technique meaning leaf printing. The process quite literally is done by beating the colour from the plant material. The colours left are more like stains, but can be made to last a reasonable time if the cloth being printed has been pre-mordanted.

This technique works well with pansies, violets and small, delicate, fresh and shapely flowers and leaves – my favourite are the leaves from the rich coloured heucheras. The cloth fabrics that work best are usually from animal fibres (protein) like silk and wool (*see* Chapter 6). The colours left behind may not last long, but they make a pretty addition to plain silk ribbons that can be used as gift wrapping around parcels or flower bouquets and even napkin ties for a dinner party in the garden.

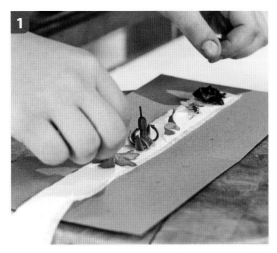

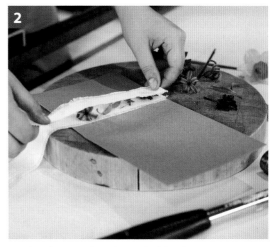

Place the ribbon fabric onto one side of the open card and then arrange the flowers or leaves on top. Make sure the plant material is not too juicy – delicate shapes are also more interesting. They can be placed individually in a row or more densely and haphazardly.

Carefully fold over the other end of the ribbon so that it is on top. This way the pattern will repeat from each end and through two layers of the fabric at the same time.

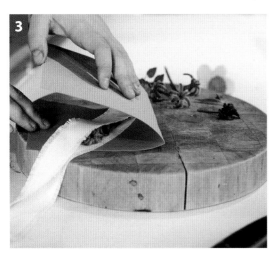

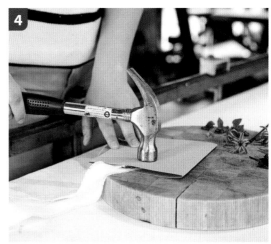

Then take the folded card over the whole ribbon layer to hold the flowers and leaves in position. The card will also give the fabric protection while hammering.

Set onto the flat wooden board and gently tap with the flat end of the hammer. You will begin to see indentations and bits of colour coming through the card. Keep going until you are satisfied that you have tapped all over.

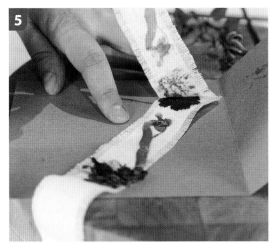

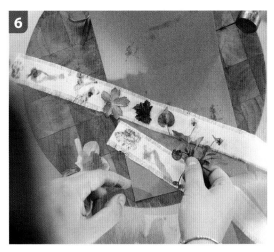

The trick is not to be too heavy handed with your hammering; the results will be more delicate and detailed if you use gentle taps rather than a few heavy blows that could pulverise the plant material.

You can carefully lift the card to check your results. Once you are happy, disassemble the package and continue the same procedure along the rest of the ribbon.

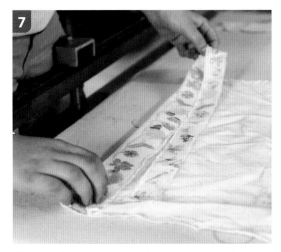

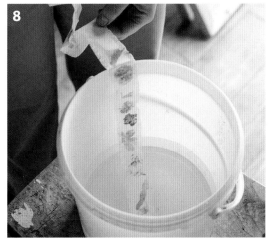

When the ribbon is well covered with colour, it needs to be steamed to set. This can be done by carefully rolling it into a neat bundle inside muslin cloth and setting it over the steamer pan for about 30 minutes or ironing over for a few minutes with a steam iron.

Rinse very gently if there is plant debris stuck in the fibres. It is not necessary to wash the ribbon if it is going to be used for wrapping.

PLANT DYES

Natural colours have been used throughout our history and some records of this are still in existence. Those used for painting – coloured minerals, earths and ochres, for example – are very stable; the coloured material being extracted from the rock or soil and ground into a fine powder to make pigments. The pigments are pure colours that can be mixed into a medium to make paint. The fine powder is insoluble so the coloured pigment is just suspended in the medium, for example in emulsion paints. It's amazing to think that this process was first used as early as 350,000BC in the Palaeolithic period. These have been evidenced in many sites; the best being seen in the Dordogne and Lot regions of France.

The natural colours used for dyeing cloth are mainly organic compounds (formed of carbon molecules) from plants and animals, which are soluble in water. Their use is likely to be as old as that of the use of pigments, but due to the fragile nature of cloth and fabrics, there is not any real evidence until around 6000BC, the Neolithic period; most being evidenced in Eastern Europe and Egypt due to the drier climate. Pliny the Elder was a first century Roman encyclopaedist who recorded that the Egyptians were using indigo, cochineal and saffron for blue, red and yellow colourants, respectively. He also claimed they invented mordanting to improve the colourfastness of the dyed cloths. It is known from various classical writers that the Romans used madder for reds, weld for yellows and indigo for blues, but any physical archaeological evidence of this remains rare.

In the Middle Ages, dyes were a very important commodity and were shipped with spices all around the world. Many people made and lost fortunes and there is a huge and interesting history around the trading and shipping of dye commodities at this time. Dyeing became a very important trade and formed its own workers' guilds in most cities. The Dyers' Guild in London received a Royal Charter in 1471 (The Worshipful Company of Dyers, dyerscompany.co.uk). In this time, the quest for new brighter colours that were washable and lightfast were sought. The better the quality of the colours, the higher the price could be achieved for the cloth. There was much conflict among the dyers – usually a two-tiered affair – and rules and regulations were administered by the city courts of the times, stipulating who could use which dyes, mordants and cloth.

From the Middle Ages to the invention of synthetic dyes in 1856, the most significant natural dyes were indigo, used in the production of denim; madder, used to make pinks and reds; and cochineal, which is still used as a food colouring today. Logwood was quite possibly the natural dye that lasted the longest in industry – until the 1930s it was still the best source of black and was used to dye men's socks.

Madder is an easy dye plant to grow, but it's best to keep it in a container as it can be regarded as a weed.

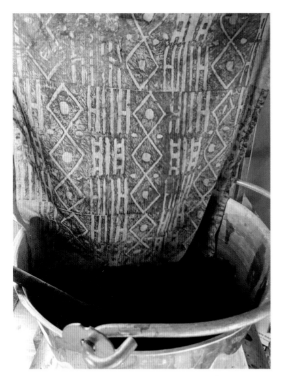

Logwood with an alum mordant gives shades of purple. The fabric in this photograph has been mordant printed before going in the logwood dye bath.

Purple was a status symbol in the Roman times and a sacred colour in religion. Throughout ancient history, wearing the colour purple was a sign of wealth. It was not an easy colour to dye onto cloth and the recipe was a highly guarded secret.

The first true purple dye was called 'Tyrian purple' and came from Mediterranean purple molluscs. Tiny amounts of the colourless dye precursor was extracted from the hypobranchial gland of each mollusc by crushing them. Pliny the Elder, in his work *The Natural History*, wrote in his recipe that it took 100kg (220lb) of this secretion for each dye vat – I'm not sure what quantity of fibre each vat dyed, but there certainly would have been a lot of dead molluscs in the time! The dyeing process wasn't straightforward and it is surprising how it was discovered. It involved mixing the gland secretions with a reducing agent like urine and exposing it to sunlight for a number of days. This reduction process turned the secretions purple. In the vat, it dyed the fibres from a very intense dark purple called 'blatta' (coagulated blood) to paler mauves in the exhaustion of the bath.

It's not surprising that there were a lot of industries making an 'imitation purple'. The oldest recipes were recorded in Babylonian times, which involved overdyeing woad with madder, mainly on wool with an alum mordant. Another common purple used since antiquity was orchil, made from lichen, which is not so colourfast and required a lot of lichen to colour a small amount of cloth. It does seem extraordinary that the first synthetic dye to be made was purple. William Perkin, a young chemist working under the director August Wilhelm von Hofmann at the newly formed Royal College of Chemistry (1845), discovered by accident the first aniline dye, naming it 'mauvine'.

Survival into the twentieth century of some natural dyes as colourants has mainly been due to prestigious designers and noteworthy craftspeople who can't see beyond the wonderful aesthetic of the natural colours

There has been much discussion around the use of synthetic dyes, and not just recently. William Morris had quite a lot to say about the newly-invented colours in his essay 'Of Dyeing as an Art' in *Arts and Crafts Essays* by William Morris, Walter Crane, et al. (1893), published online by Project Gutenberg:

It must be added that no textile ornament has suffered so much as cloth-printing from those above-mentioned commercial inventions. A hundred years ago the processes for printing on cloth differed little from those used by the Indians and Persians; and even up to within 40 years ago they produced colours that were in themselves good enough, however inartistically they might be used. Then came one of the most wonderful and most useless of the inventions of modern chemistry, that of the dyes made from coal-tar, producing a series of hideous colours, crude, livid – and cheap, – which every person of taste loathes, but which nevertheless we can by no means get rid of until we are able to struggle successfully against the doom of cheap and nasty which has overtaken us.

There is so much to know about William Morris, a Victorian legend. Much has been written about him, his art, designs and literary work. Despite this wealth of knowledge, there is not much written about his dyeing processes – most of which were learnt with a family of natural dyers in Leek, Staffordshire.

Making colours that will be easy to reproduce has been very tricky in my production of textiles for the soft furnishings market and I am rather fond of this Morris quote, also from 'Of Dyeing as an Art' in *Arts and Crafts Essays*:

The art of dyeing, I am bound to say, is a difficult one, needing for its practice a good craftsman, with plenty of experience. Matching a colour by means of it is an agreeable but somewhat anxious game to play.

PLANT COLOURS

It is wonderful to watch the reactions of people who see my printed linens for the first time. Interestingly some will walk right by and take no notice, but you can see those with inquisitive

Portrait of William Morris from Rjiksmuseum.

minds transfixed by the colours and I love telling them how they are achieved. It is safe to say that the colours achieved from nature are far superior to any synthetic dye that has followed subsequently by the manufacturing of azo dyes from crude oil.

There is so much experimentation that can be done with what nature provides and I implore you to do as much as possible. Dyeing with plant dyes is a very different skill – one that is about producing as many varieties of colour as possible from each plant material by adjusting how the cloth used is mordanted or modified with various adjuncts. This is, of course, something that could be experimented with if a certain colour is desired, but for the realms of this book and printmaking we are not going to get too involved with dyeing processes.

I have my favourite staple dye plants and not without reason. Most of them are the ones used since antiquity, which give good colours that are easy to achieve. I like working with sustainably sourced extracts for reliability of results. When using fresh plant material, I prefer that they are grown locally, require no maintenance in terms of water or fertiliser and have good light- and wash-fastness.

Table 1 lists some good dye plants; some readily available as extracts or that grow in the British Isles. This list can easily be expanded as you investigate nature's potential for your own information and records.

> **NOTE:** It is important to be careful what and how you forage; not taking large amounts of plants from one area and making sure you know what you are collecting and whether it is poisonous to handle. Also, when buying extracts, it is important to make sure they are from a sustainable source, especially those that are heartwoods; where the tree or shrub has been destroyed to produce the extract.

TYPES OF DYES

For a plant dye to be valuable in the dyeing process it needs to have a few special qualities, including producing a strong colour. Light- and wash-fastness are important if the items are to be used where washing is required.

Plant dyes fall into four categories, each defining the way the colour will interact with the cloth. Most dyes fall into the first category, so more than likely some preliminary preparations in way of a mordant to the cloth may be necessary when printing with them.

Adjective Dyes

These require a mordant to help them fix to the cloth. The mordant acts as a tie between the dye molecules and the fibres. We will have a closer look at types of mordant and how it is done in Chapter 6. Most natural dyes fall into this group.

Substantive Dyes

Substantitive dyes are the easiest to use as they will bond to the fibres without the need of a mordant, although mordants can be used to alter the colour tone or depth. This group includes those plant materials rich in tannins, like the bark and acorns of oak, eucalyptus leaves and bark, and other tree barks. All of this category can be used effectively without a mordant on protein fibres, as they have an affinity with the cloth. Only the tannin rich will give a good colour on cellulose fibres.

Fugitive Dyes

These contain the groups of substances that don't really interact with the cloth in the way of a real bond. The colours they make immediately are more like stains and are quite short-lived, so are technically not a dye at all.

Vat Dyes

Vat dyes are different to the other groups in that they require a fermentation process to make them soluble in water. This transforms them into a state that would enable them to fix to the fibres. Indigo is the main example of a vat dye. It is not possible to use them easily to print with as fermentation occurs without oxygen. Printing in the usual way with vat dyes is not possible as fermentation occurs without oxygen, making it impossible to apply it in the correct molecular form that will bond to the cloth. To obtain a pattern using indigo, resist dyeing is employed.

TABLE 1 DYE PLANT INFORMATION

Common name	Scientific name	Part to use	Colour	Type of dye
Alder	*Alnus* species	Leaves	Sage greens	Substantive
Alder buckthorn	*Rhamus fangula*	Bark and leaves	Peaches, browns and yellows	Substantive
Apple	*Malus* species	Leaves and bark	Sage yellows	Adjective Substantive
Ash	*Fraxinus* species	Leaves	Golds and beiges	Substantive
Blackberry	*Rubus fruticosus*	All parts	Violets with berries and grey-browns	Substantive
Birch tress	*Betula* species	Leaves and bark	Yellows	Adjective Substantive
Bracken	*Pteridium aquilinum*	Leaves	Golds and browns	Adjective
Brazilwood	*Caesalpinia echinata*	Heartwood extract	Reds	Adjective
Coreopsis	*Coreopsis* species	Flowers and tops	Yellows and browns	Adjective
Cutch	*Acacia catechu*	Extract from heartwood	Oranges and browns	Substantive
Daffodil	*Narcissus species*	Fresh flowers	Yellows	Adjective
Dahlia	*Dahlia* species	Flowers and leaves	Greens and golds	Adjective
Dyers alkanet	*Alkanna tinctoria*	Extract	Greys and purples	Substantive
Dyers chamomile	*Anthemis tinctoria*	Flowers and leaves	Acid yellows and greens	Adjective
Dyers greenwood	*Genista tinctoria*	Plant tops	Yellows and sages	Adjective
Elderberry	*Sambucus* species	Leaves and bark	Yellows/sages and pastel shades	Adjective Substantive
Eucalyptus	*Eucalyptus* species	Leaves	Oranges and browns	Substantive
Hawthorn	*Crataegus* species	Berries, leaves and flowers	Yellows, golds and browns	Adjective
Hollyhock	*Alecea rosea*	Flowers	Pinks and purples	Adjective
Ivy	*Hedera helix*	Berries and leaves	Sage greens and greys	Adjective
Ladys bedstraw	*Galium*	Roots	Reds	Adjective
Madder	*Rubia tinctorium*	Roots	Reds and tans	Adjective
Mahonia	*Mahonia* species	Leaves, berries and flowers	Pale mauves and pale grey-greens	Substantive
Marigold	*Calendula officinalis*	Flowers	Pale yellows and greens	Adjective
Onion	*Alium cepa*	Skins	Yellows	Substantive
Oak	*Quercus* species	Leaves, bark, galls and acorns	Pinks, yellows greens and browns	Substantive
Potentil	*Potentilla tormentilla*	Roots	Reds	Adjective
Rhubarb	*Rheum* species	Leaves and roots	Oranges and sages	Substantive
Rose and dog rose	*Rosa* species	Leaves	Yellows	Adjective
Rose mallow	*Hibiscus* species	Flowers	Purples	Adjective
Sumac	*Rhus species*	Leaves and berries	Yellows and oranges	Substantive
Walnut	*Juglans* species	Leaves and husks	Golden yellows	Substantive
Weld	*Reseda luteola*	Tops and flowers	Yellows and golden browns	Adjective
Willow	*Salix* species	Bark and leaves	Yellows/greens and pale pinks	Substantive Adjective
Yarrow	*Achillea millefolium*	Tops (leaves and flowers)	Yellows/greens	Adjective

Ashley and Susan are the team of two behind Nature's Rainbow, based in Hitchin, Hertfordshire. Together they have established an allotment full of dye plants that they experiment with. It was a childhood memory of Ashley's trying to make some lovely red paint from a bowl of berries that he had seen in a book about Stone Age people, which triggered – many years later, of course – the desire to investigate these things further.

Starting out, Ashley bought seeds of the three core dye plants: woad, madder and weld, thinking if he had a blue, red and yellow dye he could achieve the remaining colours of the spectrum with overdyeing. Here, Ashley from Nature's Rainbow writes about his journey with growing and using dye plants in the UK.

DYE PLANTS BY NATURE'S RAINBOW

It took a number of years, during which there were a few setbacks and occasional successes, before we were able to produce enough dye material to start dyeing textiles. With the help of Jenny Dean's *Wild Colour* and Jill Goodwin's *A Dyer's Manual* we were off on a journey that has taken a hold on us and not let go.

DYE PLANTS

Woad

Of all the indigo-bearing plants, woad is the only one really adapted to a temperate climate. It is naturalised in the UK, but originally was introduced from Western Asia. Its native habitat is dry plains, which explains why it's such an invasive pest in the American West. Here in the wetter UK, however, it cannot easily compete with our native plants.

Frost hardy and very robust, it needs little maintenance and will self-seed if given half a chance. Rather surprisingly it is a member of the cabbage family but fortunately not one that attracts all the pests. Like many garden

vegetables, it is a biennial, which means it usually flowers in the second year and then dies. It is the first year 'rosette' leaves that are used to extract indigo dye. Growing woad is much the same as growing any cabbage – they need good

Woad plant in full flower (*Isatis tinctoria*).

fertile soil and only occasional watering. Don't try eating it though, as it tastes very bitter and nasty! Extracting the indigo is another matter and is not so easy.

Weld or Dyer's Rocket

We are fortunate in having weld as a native local wildflower as it is considered by many to be one of the most lightfast and versatile sources of yellow dye in the world. It is native to most of Europe, Western Asia and North Africa. It is sometimes described as a pioneer plant because it is usually found growing in disturbed or waste ground.

Weld is another biennial with a long tap-root-like woad. It usually flowers in its second year when it is harvested at its maximum size. It produces a very bright lemon-yellow dye, which is ideal for combining with indigo from woad to produce various shades of green and was probably used to make 'Lincoln green' of Robin Hood fame.

Propagating weld is actually quite tricky as the seed is tiny and seedlings are easily crowded out by other plants or eaten by pests. It has a reputation for growing where *it* wants and not where the gardener wants. Transplanting usually results in rapid death. Like many people, our first experience of trying to grow weld resulted in failure, but over the years we have got to know its foibles and now have a foolproof method of propagation.

Common Madder

This is a native plant from the Eastern Mediterranean to Central Asia, in particular Iran and countries bordering the Caucasus mountains. It was grown in the UK for a while, but it was not economic without the right soils or climate. It is a perennial member of the Rubiaceae family, of which the coffee plant is also a member. Its closest UK relative is cleavers or goosegrass (*Galium aparine*), to which it bears a strong resemblance, particularly in its ability to stick to your clothes. However, there is no mistaking

Weld or dyer's rocket (*Reseda luteola*).

Fresh madder roots that have been washed.

madder as it is altogether a much larger plant! This makes it sound like a potentially invasive plant, and indeed it can spread by underground stems, but it does not spread by seed as all seedlings are usually killed by frost. Provided

it is either grown in containers or its invasive underground runners are dug out, it can be relatively easy to keep under control.

The only other native sources of red dyes are lady's bedstraw, hedge bedstraw and wild madder, which are also members of the Rubiaceae family, but although these were used in times gone by, they do not produce anything like the quantity and quality of red dye as common madder. The red dye is obtained from the roots and underground stems, which can be used fresh or dried for later use.

> **NOTE:** It is illegal to take roots from plants in the wild in the UK without permission from the landowner or occupier. You should always check your local laws protecting wildlife.

Since 2022, we have taken to growing another species of madder: *Rubia Cordifolia* (Indian madder or munjeet). In appearance and behaviour it is very similar to common madder, but as a tropical plant from India, parts of Asia and most of Africa, it's much less frost hardy so needs to be grown in a greenhouse or polytunnel. The advantage of Indian madder is that the plant tops can also be used for a red dye and the leaves for botanical prints.

Dyer's Chamomile

Always a favourite, since we started growing dyer's chamomile it is now one of our top recommendations for the dye garden. Producing a mass of very showy, yellow, daisy-like flowers, it is a decorative addition to the garden. It is usually described as a weak perennial as it rarely lives beyond two years in many parts of the UK. Like madder, it originates in Western Asia and will live longer in a hot, dry climate. However, it is fairly hardy and will put up with the more usual wet and cool winter conditions in the UK.

Dyer's chamomile is easy to grow and requires little maintenance or watering. Its seeds are very fertile and long-lasting. It can also be grown from cuttings, but sowing seed is probably a lot faster and easier. It will self-seed readily and seedlings grow rapidly – they should start to flower by midsummer and will continue until the first frosts of winter. In its second year the plants flower in early summer but often die before the summer is over.

The flowers are harvested for a golden yellow dye at regular intervals, but the foliage also contains some dye. Dyes from flowers are usually not as lightfast as red from madder or indigo blues, but chamomile was used traditionally to dye wool for Persian carpets. So, provided dyed textiles are not regularly placed in direct sunlight, it will last a long time.

Dyer's chamomile (*Cota tinctoria*).

Advice from Nature's Rainbow on Starting Your Own Dye Garden

If you are starting a new dye garden, we recommend first asking yourself a number of questions to help you to decide which plants to include or leave out.

1) How much time will you have available for gardening?

If your primary occupation is making textiles, you may want to be spending most of your time doing that and not weeding, watering and digging. To that end, you should be choosing plants that can mostly take care of themselves and perhaps perennials rather than annuals.

2) Do you go away on holidays or travel a lot? If so, do you have any help with watering or harvesting while you are away?

So often we meet 'would be' gardeners who depart the country every summer just at the point when it's time to harvest or water parched crops.

3) Do you want to grow dye plants as a crop or as a decorative garden plant? Or both?

The answer to this question will affect your garden layout and planting scheme. You could, for example, grow all the plants in rows like vegetables with ample access between rows for easy maintenance and harvest. Whatever you decide, access to the plants is important because you may be harvesting or watering on a regular basis and you will wish to avoid walking on soil or damaging other plants to get to them.

4) How much space do you have?

Some plants produce a lot of dye for a relatively small amount of plant material and others the opposite. So, if your space is very limited, it is best to concentrate on the plants that give the highest yields. If you have little or no bare soil you may prefer to grow plants in a series of containers.

5) What is your local climate and soil like?

Many good dye plants originate in warm climates, so in northerly or exposed locations you may need to provide the protection of a polytunnel or greenhouse. Some plants have preferences for more acid or more alkaline soils. For example, weld likes neutral to alkaline soil, whereas woad is not fussy.

6) What is your main interest in dyeing?

Natural dyes are very variable; some are better for animal fibres than cellulose. If you are more interested in botanical printing, your choice of plants will often be quite different.

Recommendations from Nature's Rainbow on Getting Started

1) Start with a few key plants (woad, weld and madder) and really get to know them by growing from seed. This way you know what the young seedlings look like if they start to self-seed in your garden.

2) Get a good book on permaculture, e.g. *The Permaculture Garden* by Graham Bell.

3) Initially plant in blocks or rows of one species with easy access for maintenance. Some plants can be grown with others and with everyday garden flowers, herbs or vegetables potager style, but many are either easily crowded out or will in turn crowd out others.

4) Check out the Nature's Rainbow website, where there is much more information on particular dye plants: www.naturesrainbow.co.uk.

What is Your Favourite Job in the Garden?

Our favourite activity in the garden is watching the plants grow and observing the insects that come and visit them. We were delighted to observe that many of these plants are of significant value to various insects. For example, madder is a food for the hummingbird

hawk-moth caterpillar and buckthorn for the brimstone butterfly. Weld and Japanese indigo are great bee plants.

Jobs-wise, the favourite has to be starting off the seeds in early spring. Some seeds are quite difficult to germinate so when they do it's always an exciting moment. The main jobs of digging, planting out, watering, weeding and harvesting are repetitive, but like all such tasks should be treated as an opportunity for meditation as well as a good source of fresh air and exercise. With each finished task, there is a deep feeling of satisfaction.

What Keeps You Focused?
Well, there is always something new to learn about these plants. For example, we have five varieties of Japanese indigo and learning the differences between them is endlessly interesting. Occasionally we get our hands on a plant that has been used as a dye plant in the past but has not been tested in modern times. This is always exciting and sometimes we find that these plants are much better than currently thought. The way that the plants are grown is sometimes of critical importance, so we are in a way reviving the use of these old plants.

Dye plants can be grown in tubs. This is a large tub of woad by the Madder Cutch & Co. print studio.

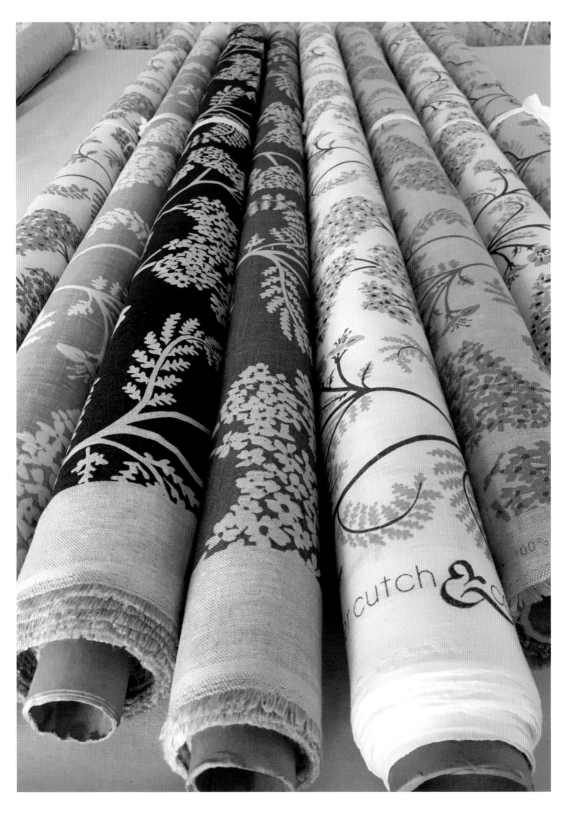

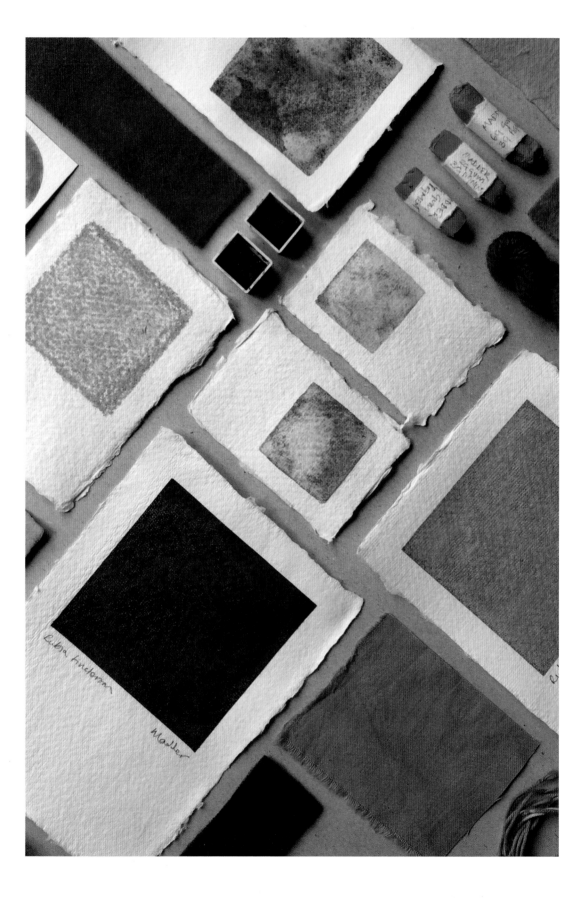

PRINTING RECIPES AND CLOTH PREPARATION

The amount of colour potential from nature is quite versatile when dyeing with natural dyes. Turning the dyes into print pastes that will give a good colour once printed on cloth can be a bit trickier. The methods and techniques used over the hundreds of years when only natural colours were available is interesting but complex for our purposes. Most of the techniques used for printing the colour directly onto the cloth require several stages and a lot of rinsing and washing. For this reason, the dye paste recipes we will make in this chapter are relatively simple, even for a beginner.

Table 1 (*see* Chapter 5) gives information about types of dye plants. Some will be better than others when made into printing pastes. This is something you will be able to experiment with; developing your own techniques based on what you learn and experience. You will work out what you use is dependent on what you are wanting to achieve. By experimentation and record keeping, you will soon be on your way to becoming an expert.

Printing a length of 'Achillea' with my brother.

Colour of madder by Jacqui Symons of Slow Lane Studios.

Jacqui Symons from
Slow Lane Studio

Jacqui has been experimenting and researching the use of plant-based pigments since 2018. She currently runs printmaking, natural dye workshops and courses around the country and is developing Slow Lane Studio to become a centre for natural colour and print, from conception through to creation.

My favourite dye plant to work with has to be madder (*Rubia tinctorum*) every time. I was already biased because my favourite colour is red, but the variety of reds, oranges, purples and pinks that you can coax from the roots of the madder plant is fantastic. I also love indigo, rhubarb root and coreopsis but my preferences do change depending on what printmaking techniques I'm using.

If you're thinking about printmaking with natural dyes, just have a go. You don't need to worry too much about recipes and results the first few times – the main thing is to experiment and test different ideas. However, I have found it invaluable to write copious notes on everything I do and always label your results – every time I think I'll remember what I did to achieve a certain colour and I never do.

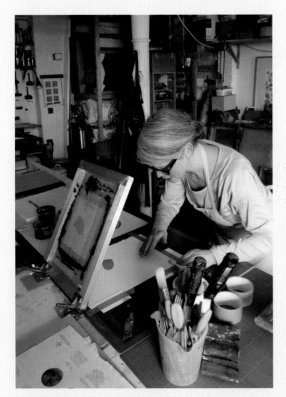

Jacqui in studio with hinged press.

Sunday Flapjack (Jacqui Symons).

MAKING PRINT PASTES

Using Readily Available Dye Extracts

It is very easy to buy natural dye extracts, and if you feel more comfortable starting off this way I recommend you buy just a few to begin with and store them in a glass jar with a proper-fitting lid and a dated label. Good staples include: madder, weld, dyer's greenwood, cutch and cochineal. You should always make sure the dyes are from a sustainable source.

The recipes below are based on starting with a solution of dye extract. This is easily done with powder extracts by dissolving the right amount into warm or cold water to make the solution required.

Extracting the Colour From Fresh or Dried Plant Matter

If you like foraging or have the luxury of a well-stocked garden, this is a satisfying route to take. You can use fresh plant materials as listed in Table 1 (*see* Chapter 5) or you can experiment with some different ones to see what they yield. Essentially, in this stage, you are going to be a natural dyer, but instead of having a lovely big dye bath to take a lot of fibres, we need to use only a small amount of water to end up with a very concentrated solution, so we use jam jars rather than a big dye pot.

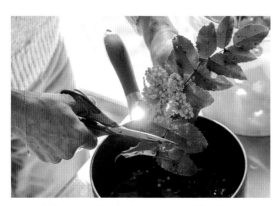

Mahonia flowers and leaves being prepared for the dye pot. The plant fibres should be cut or chopped as small as possible to increase their surface area.

The general rule for dyeing is 100g (3½oz) of cloth to 50–100g (1¾–3½oz) of fresh or dried plant material. I tend to find that this translates well into making 200ml (6¾fl oz) of printing paste, which will print roughly 1m² (39in) of fabric, depending on the amount of coverage of your design.

The plant material needs to be chopped up quite small to enable it all to fit in a jam jar, but you can scale up or down according to which plant material you are using and what printing method you have in mind.

I prefer to make fresh pastes for each printing session to get the best attachment of colour to the cloth. The colours can form a liking to the paste thickener and therefore less will be available to bond to the cloth on printing the longer the paste is left.

A water bath is used in this method as its best to collect the concentrate below boiling point and a water bath is the best way to control this. Boiling some dye plant matter will affect the quality of the colour.

EQUIPMENT AND MATERIALS

Makes about 200ml (6¾fl oz) of concentrated extract

- Jam jars (500ml/17fl oz size with a wide brim are best)
- Dye pot or large pan to use as a water bath
- Plant material (50g/1¾oz)
- Small teaspoons for stirring
- Coffee filter cut into a circle
- Funnel
- Clean storage jars

Method

1. Set up the water bath using a large pan or even your dye pot. Use enough water to come halfway up the side of the jam jars.
2. Fill the clean jars with as much of the 50g of plant material as possible, chopping or cutting it into small pieces so that it fits. Then pour over boiling water to fill half the jar.
3. Simmer the jars in the water bath for around an hour until you can see the solution turning a rich colour. They can be left to cool in the bath before decanting the solution through the filter paper into a clean storage vessel or a jar that has a lid.
4. The filtrate should be clear, containing no bits. Refilter it if necessary. Once clear, the filtrate is now ready to be used in a dye paste recipe. You should have around 200ml (3½–5fl oz) of extract. It can be used warm or it can be stored for a few weeks in a cool place out of direct sunlight. Don't forget the label.

Plant fibres need extracting in small amounts of water to make a concentrated dye solution.

Plant fibres in jam jars in a water bath to make a concentrated dye solution.

Method 6.2: Dye Print Pastes Without a Mordant

EQUIPMENT AND MATERIALS

- 200ml (6¾fl oz) dye solution from extraction or dissolve 5–10g of dye extract in 200ml (6¾fl oz) warm water
- 5–10g cornflour or 2–4g of guar gum (depending on the printing process)
- Beaker or wide-brimmed jam jar
- Small teaspoons for stirring
- Dye pot or large pan to use as a water bath
- Hand blender or fine sieve (optional)

Whether you are using a readily available powdered dye extract or your own extracted colours, this recipe is simple and can be made and used immediately, or stored in an airtight container for around two weeks. While this printing paste can be used with any dye colour, the lack of a mordant will not help fix adjective dye colours to cloth, so if using this recipe for these dyes the cloth should be pre-mordanted. The best use for this paste is on papers where no washing will be necessary. If using a dye extract, experiment with the quantity to use. Always add less to start with. If a stronger colour is desired, more extract can be added.

I prefer to use different thickeners for block and screen printing. When block printing, I find it is easier to apply the paste with a sponge, and to get sufficient ink onto the block I prefer the flour thickeners; they cover the block surface in a better way than the gum thickeners that tend to gel together. The gums are good for screen printing; having a thicker consistency, they produce crisper prints with no seeping.

Method

1. Pour the extract solution into a beaker or wide-brimmed jam jar, then carefully sprinkle in the cornflour whilst stirring.
2. The paste will need to be placed in the water bath to thicken it – a bit like thickening a gravy or sauce. Stir constantly until the paste has thickened and become more translucent in texture.
3. If using a gum thickener, the gum powder should be added to a cold solution a small amount at a time with thorough stirring. I find the gums quite easily go lumpy and the best way to deal with lumps is to use a hand blender to whizz it, or you could push it through a fine sieve.

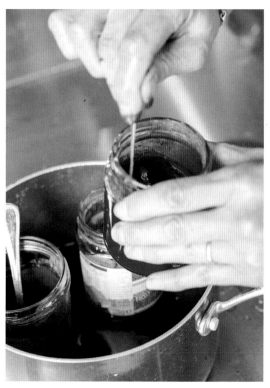

When using a starch thickener, the paste will need constant stirring while warming in a water bath.

Makes 1 litre (1¾ pints)

- 50g (1¾oz) alum
- 1 litre (1¾ pints) white vinegar
- 20g (¾oz) guar gum
- Large container
- Handheld stick blender
- Steamer

Using a stick blender to make up the dye pastes helps remove lumps to make a smooth paste.

Method 6.3: Making a Batch of Print Paste Thickener (With Mordant)

Adjective dyes need the help of a mordant to fix them to the cloth and instead of mordanting the cloth before printing, the mordant can be included in the dye paste. When the dye colour is included with the other ingredients (*see* Method 6.4), it has a short life (to be used within a day), so I prefer to make up a batch of the print paste without the colour and then use it when required.

> **NOTE:** I find this method is best suited to use with screen printing. I prefer to use starchy thickeners (flours) when block printing, but the presence of vinegar in this recipe prevents the starch thickening – they are degraded by the acid.

Method

1. Dissolve the alum in about 200ml (6¾fl oz) of the vinegar, then add to the rest of the ingredients in a large enough container and blend to a smooth paste with a handheld stick blender.
2. Allow 30 minutes for the paste to finish thickening before taking out the desired amount to make the printing paste.
3. The prepared paste is quite thick. Using a dissolved extract or an extracted solution of dye will improve the consistency of the paste for screen printing. If using for block printing you may need to make it even thinner by adding more dye solution.
4. The paste can be stored in an airtight container for up to a month, and used as you need it.

Method 6.4: Making a Ready-to-use Dye Paste with a Mordant

This is a quick method of making a print paste that contains the dye colour and a mordant. The exact amount of dye extract to use will vary, depending on the dye. The extract in solution could be concentrated by evaporation or, if using a powder extract, it can be dissolved into the aluminium acetate solution. As a general guide, 1–10 per cent is usually sufficient, depending on the dye. Always weigh the extract as accurately as possible and add in increments until the desired depth of colour is achieved.

Method

1. Dissolve the aluminium acetate in a small amount of hot water. Allow to cool before mixing in the dye extract solution. Thicken with a gum thickener using a handheld stick blender to avoid lumps.
2. For block printing with this paste, add more than 200ml (6¾fl oz) of the dye extract solution, or add less gum thickener, or use cornstarch to thicken the solution.
3. The finished prints should be dried thoroughly, steamed for 15–30 minutes and then neutralised in a chalk bath before washing in a pH-neutral soap.
4. The paste will not keep long, so only make what is required.

EQUIPMENT AND MATERIALS

Makes about 200ml (6¾fl oz)

- 200ml (6¾fl oz) dye extract solution (*see* Method 6.1) or 2–20g of dye extract powder
- 5g aluminium acetate, dissolved in hot water
- 2–3g gum thickener
- Handheld stick blender
- Steamer
- Chalk bath
- pH-neutral soap

Dabbing a small amount of the dye paste onto some cloth to reveal the colours.

Makes about 200ml (6¾fl oz)

- 20g (¾oz) alum
- 10g (¼oz) soda ash
- 200ml (6¾fl oz) vinegar
- 2g gum thickener
- Dye extract (a very small amount)
- Cloth
- Whisk/stick blender
- Block/screen for applying paste
- Hairdryer or iron
- Calcium carbonate solution
- Dye bath

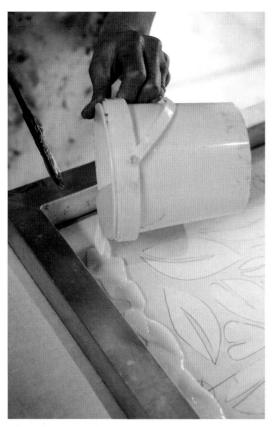

The mordant print paste is colourless. If you wish to see your printed areas more easily, a small amount of a dye extract can be added to the paste.

Method 6.5: Making a Mordant Printing Paste (No Dye)

Mordant printing is perhaps the most traditional way that cellulose fibres were printed in the past. This method gives the sharpest definition, and better colours are achieved during dyeing than using the paste directly. In mordant printing, the cloth is printed with a tinted mordant, the mordant is set into the cloth, and then on dyeing only the mordanted areas will take up the colour. In this type of printing, it is best to use an adjective dye as the unmordanted areas will not take up any colour, unlike with a substantive dye, which can colour the unmordanted areas of the cloth, but to a lesser extent and not as intense or bright a colour, depending on what mordant is used for printing.

Method

1. Dissolve the alum and soda ash in the vinegar. It will fizz. Allow the fizzing to stop then whisk in the gum to thicken the paste a small amount at a time. (Use a stick blender if it goes lumpy.)
2. The mordant paste is colourless, so to help you see where you are printing, add a small amount of dye extract to give a faint colour. Apply the paste to the cloth with a block or through a screen.
3. Allow the paste to dry on the textile. Use a hairdryer or iron to make sure it is thoroughly dry, then neutralise in the calcium carbonate solution for 10 to 20 minutes, depending on thickness of the cloth. Wash thoroughly in warm water to rinse out the thickener before adding to a prepared dye bath.

Dyeing is such an exciting way to use plant dyes and perhaps the most natural. There are plenty of dye books available. When I was at college I certainly fell in love with Ethel M. Mairet's *Vegetable Dyes: A book of recipes and information useful to the dyer*, which was first published in 1916, but my favourite and most reliable author is Jenny Dean. A general guide is to use the same weight of dye plant material as the weight of the cloth to be dyed, to get a good shade of colour.

Method

1. To dye 100g (3½oz) of cloth, you will need up to 100g (3½oz) of fresh or dried plant fibres, depending on the intensity of colour desired and the plant material being used. Cut or chop the plant fibres into small pieces to increase their surface area available to collect the dye particles.

2. Soak in water for up to a week (especially good when using barks), prior to extracting, to help the process. Otherwise, pour over boiling water and leave for an hour or so before heating up to a gentle simmer. Keep the temperature just below a simmer for an hour. This method will vary depending on the dye plant material, and it is advisable to experiment first or research a method in a good dye book, like Jenny Dean's *Wild Colour*.

3. After simmering, sieve the extracted colour into a dye pot, large enough to take the fabric being dyed. The fibres should be fully submerged when in the dye pot. Some dyes can be used in a cold dyeing method, so experiment first. If using the hot dyeing method, the fibres should be simmered for 30 minutes to an hour. You can check the colour as you need to, stirring from time to time.

4. When you have the colour to your liking, allow the fibres to cool in the pot overnight before removing and rinsing.

Chopped-up alder buckthorn bark being added to the water to make a dye bath.

Cloth fibres being added to the dye pot, making sure they are evenly immersed and have room to move freely.

TABLE 2 OVERVIEW OF PRINT PASTES METHODS

Project(s) the paste can be used in	Printing paste recipe	Fabric to print and preparation	Ingredients
2.1, 2.2, 2.3, 3.1	**Method 6.2: Dye print paste** Printing paste containing dye colour only	• Papers • Pre-mordanted cloth • Steam to set • Rinse and wash	**Makes 200ml (6¾fl oz)** • 200ml (6¾fl oz) dye extract solution • 2–4g of a gum thickener *or* 5g cornflour for block printing
3.1	**Method 6.3: Mordanted thickened print paste** Printing paste thickener premade, ready to add dye colour	• Silk (animal fibres) • Cotton/linen (cellulose fibres) • Steam to set • Neutralise • Wash in pH-neutral soap	**Makes 1 litre (34fl oz)** • 50g (1¾oz) alum • 1 litre (34fl oz) white vinegar • 20g (¾oz) guar gum
2.2, 2.3, 3.1	**Method 6.4: Mordanted dye print paste** Printing paste containing the dye colour and mordant	• Silk (animal fibres) • Cotton/linen (cellulose fibres) • Steam to set • Neutralise • Wash in pH-neutral soap	**Makes 200ml (6¾fl oz)** • 200ml (6¾fl oz) dye extract solution • 5g aluminium acetate dissolved in hot water • 2g of a gum thickener for screen printing *or* 5g cornflour for block printing
3.2	**Method 6.5: Mordant paste (no dye)** Mordant printing paste applied pre-dyeing	• Silk (animal fibres) • Cotton/linen (cellulose fibres) • Neutralise in chalk solution • Rinse well before adding to the dye bath	**Makes 200ml (6¾fl oz)** • 20g (¾oz) alum • 10g (¼oz) soda ash • 200ml (6¾fl oz) white vinegar • 2g gum thickener

Drying the prints with a hair dryer helps speed up the process.

Dye colours made into corn starch paste warming in a water bath.

WHAT TO PRINT ON AND PREPARATIONS

There are three main groups of textiles: protein (animal fibres like silk and wool), cellulose (plant fibres like cotton and linen) and synthetic.

Synthetic fibres are not easy to dye and certainly won't entertain natural dye colours. Animal fibres are the best at taking up plant-based colours, but only silk is suitable for printing on; the print processes and pastes not being able to penetrate the surface fibres of most wool fabrics. The recipes and techniques I have covered in this book are primarily for cellulose fibres as I feel they have the biggest call for printing and are easier to work with because they are more robust and can handle the higher temperatures of preparations and finishes.

Method 6.7: Scouring Fabrics Made From Cellulose Fibres – Cotton, Linen, Hemp, Sisal

When dyeing fabrics to achieve a nice, even, uniform colour, this step becomes very important – especially if the fabrics are being repurposed. They may look clean after washing in the machine, but sometimes stubborn stains like grease will not be removed and the scouring process is a good way to get rid of everything, including any leftover detergent. This step should still be carried out for new fabrics as there could be finishes left from the manufacturing process. Although we are mainly concerned with printing fabrics in this book, it will still be necessary to scour and clean the cloth fibre so they take up mordants to help set the colour prints on the cloth.

To scour 100g (3½oz) of cloth, the following will be required. It's a good idea to weigh the cloth and preliminaries to avoid waste. You will probably want to scour more than 100g (3½oz) at a time, and so you can easily work out how to increase the quantities from the instructions below. If you have reasonably new cloth, remember the fabric may shrink.

EQUIPMENT AND MATERIALS

- 2.5g soda ash (washing soda)
- 2.5g soap powder (neutral soap like Ecover, or I use a squirt of washing-up liquid)

Method
1. Mix the soda ash and soap powder into a pan large enough to take all of your cloth.
2. Add the cloth to the pan, and boil for 1 to 2 hours, stirring occasionally. The water will look dirty if the cloth contained any residual treatment chemicals.
3. Remove carefully into a clean bucket and rinse thoroughly.
4. Dry and store for later or spin and use directly in the mordanting stage, if a pre-mordant is necessary.

After boiling for an hour or so, the scouring water may begin to look dirty.

Method 6.8: Mordanting Fabrics with a Metal-based Mordant

Most of the projects in this book will not require this mordanting stage, as the printing pastes will contain the mordant where necessary. However, if you prefer to use unmordanted printing pastes (which are easy to store for a longer period), you can do so by making sure the cloth being printed is pre-mordanted. I only use aluminium salts as mordants and in my pastes as it is the most straightforward to use and gives brighter colours compared to iron salts.

For every 100g (3½oz) of cloth to mordant, the aluminium acetate should make up 5 per cent of the value.

EQUIPMENT AND MATERIALS

Quantity to mordant 100g (3½oz) of cloth

- 5g aluminium acetate
- Cloth
- Large old pan with lid

Method

1. A large old pan with a lid can be used exclusively for mordanting. Use plenty of water so it covers the fibres and gives them room to move freely.
2. The cloth can be added straight from the scouring step, or if it has been dried should be soaked in water for a good 12 hours before adding to the mordant bath.
3. Simmer the cloth with occasional stirring for around an hour.
4. Allow the cloth to cool in the bath and, once cool, carefully remove and rinse in cold water.
5. Allow to dry if it is to be used for printing or use straight away for eco printing or dyeing.

Method 6.9: Mordanting with a Natural Mordant

Natural mordants include tannins, oxalic acid, citric acid and acetic acid. While the acids are easier to use directly, tannin extracted from plant leaves and barks give much better wash-fastness results when used as a mordant; however, it does tend to dull the colours compared to aluminium salt mordants.

There are quite a few easy-to-collect plants that are rich in tannins. These include oak acorns and leaves, sumac leaves, bramble leaves and rose leaves, especially dog rose.

EQUIPMENT AND MATERIALS

- 100g (3½oz) of tannin-rich plant material for every 100g (3½oz) of cloth to be mordanted

Method

1. Once collected, add the tannin-rich plants directly to hot water. Simmer for an hour to extract the tannin.
2. Sieve off the plant material and add the cloth to the debris-free tannin solution; around 100g (3½oz) of plant material for every 100g (3½oz) of cloth to be mordanted. Make sure the cloth is submerged and has room to move. The cloth can be added straight from the scouring step, or if it has been dried should be soaked for a good 12 hours in water before adding to the mordant bath.
3. Simmer the cloth with occasional stirring for around an hour. Allow the cloth to cool in the bath and, once cool, carefully remove and rinse in cold water. Allow to dry if it is to be used for printing or use straight away for eco printing or dyeing.

NOTE: Tannin can be bought as an extract. It will be more concentrated so only 10g (¼oz) for every 100g (3½oz) of cloth will be required.

Method 6.10: Neutralisation Solution (or Dunging)

This step is important when using acids in the print pastes. Most of the acid will have evaporated out on drying the fabrics, but this step is essentially a further neutralising measure. In the traditional methods of calico printing, this step used dried cows' dung, hence the name dunging.

EQUIPMENT AND MATERIALS

Makes a bucketful

- 10g (¼oz) calcium carbonate per 1 litre (34fl oz) of water
- Small pot
- Bucket
- Printed cloth

The neutralising solution is made from calcium carbonate or chalk that has been added to water.

Method

1. Dissolve the calcium carbonate in a smaller pot with hot water.
2. Add to a bucket of water, large enough to take the cloth you have printed.
3. This solution can be kept until it looks dirty, when it may affect the cloth being added.

TABLE 3 PREPARATIONS AND OTHER RECIPES SUMMARY

Method	Application	Ingredients
Method 6.6 General dye bath method for natural dyes	Dyeing the cloth a plant colour	• 50–100g (1¾–3½oz) fresh or dried plant material to dye 100g (3½oz) cloth
Method 6.7 Scouring cellulose fibres	Preparation of cloth prior to dyeing or printing	• 2.5g soda ash and • 2.5g soap powder to scour 100g (3½oz) cloth
Method 6.8 Mordant solution (metal-based)	For pre-mordanting cotton, linen or silk	• 5g aluminium acetate to mordant 100g (3½oz) of cloth
Method 6.9 Natural mordant solution	For pre-mordanting cotton, linen or silk	• 100g (¾oz) plants rich in tannins to mordant 100g (3½oz) of cloth
Method 6.10 Neutralisation solution (dunging)	For neutralising pastes containing acetate or vinegar	• 10g (¼oz) of calcium carbonate per 1 litre (34fl oz) water

GLOSSARY OF SUNDRIES REQUIRED FOR THE PROJECTS

You will not require all of the substances below unless you intend to print using every method suggested in this book. So, rather than rushing out to buy them all, work through a project at a time and only buy what you need. It is a good idea to keep them in labelled jars with well-fitting lids and date them if you are transferring them to a container. Most are sold in cardboard boxes and I think become vulnerable to absorbing moisture.

> **NOTE:** Keep all of your chemicals and sundries on shelves away from children and pets. Be very careful when handling fine powders, cleaning up any spills immediately with a damp sponge, which should be close at hand when handling the powders. Wear as mask if necessary.

Alum (Mordant)

This term is used to cover a variety of aluminium salts that will give aluminium as our free ion for mordanting. That said, the most popular and commonly available salt is potassium aluminium sulphate dodecahydrate [$KAl(SO_4)_2.12H_2O$] and this is what most texts are referring to as alum. Other aluminium salts that are readily available to the dyer are aluminium sulphate [$Al_2(SO_4)_3$] and aluminium triacetate [$Al(CH_3CO_2)_3$]. (I refer to this as aluminium acetate.)

I prefer to only use aluminium mordants; they produce the best colours from the dyes and are relatively inexpensive. I also prefer not to have lots of different chemicals in my studio. My go-to mordant for the cellulose fibres is aluminium acetate.

Calcium Carbonate

$CaCO_3$ or chalk is a mild alkali in the presence of an acid. It is used in the neutralisation mixture (dunging solution).

Soda Ash (Washing Soda)

Sodium carbonate $[Na_2CO_3]$ is required when making aluminium acetate from alum. Sodium carbonate is a mild alkali, readily available from hardware stores, is a good cleaning product. It is used to make an acetate of aluminium in a mordant print paste. This alkali can improve solubility in indigo and woad vats. It is also used to scour fabrics before mordanting.

Guar Gum

Coming from a bean that is mainly grown in India, guar gum is an effective thickener for screen-printing pastes. Used in the food industry as a thickener, it is colourless and keeps well in an airtight container when mixed.

Gum Tragacanth

Similar to guar gum, it is also a hydrocolloid substance that forms a gel when mixed with water. It is used in the food industry as a thickener and is colourless, so is a good choice for making printing pastes.

CMC

Carboxymethyl cellulose is a man-made hydrocolloid and is mainly used as a hardener in cake icing. It is relatively cheap and easy to buy and it goes a long way. Like the gums, it mixes to form a jelly-like paste and is better in screen printing than block. It can be found as Tylose, which is a trade name for it.

Wheat Flour/Cornflour/Rice Flour

These all have similar properties when it comes to making the flour pastes, which I prefer for block printing. They thicken the dye colours without the gelling, so can be applied using a sponge or through an inking pad.

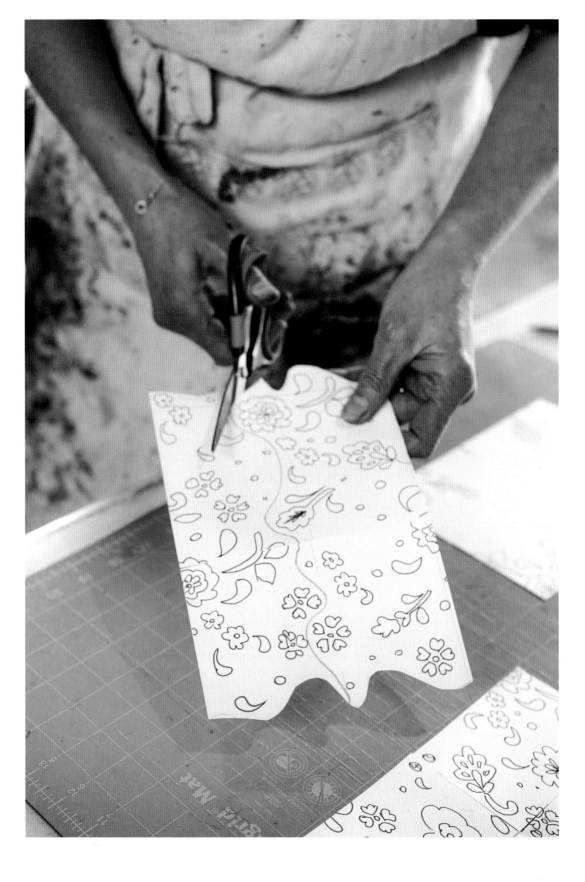

DESIGNING YOUR PRINTS

What inspires us is the very essence of where a design begins. Finding ways to translate this inspiration into designs will become a sequence that you will naturally follow and tailor to your own strengths, leading you to a unique and individual style. What will soon become a simple process will nearly always start with a mark-making exercise. Collecting these in notebooks for future inspirational reference is essential. Eventually you will become more practised at producing your own work and will understand why this is so pleasing and important as a design principle.

I often think this is the best part of the whole print process; its what everything hangs on and of course there is no right or wrong. The initial idea is just manipulated to suit what you want from it. I love this stage, from that initial seed to the final piece of artwork. Sometimes the process is very short and easy to get into the format I want, but sometimes it takes longer and requires several sketches and manipulations until I am happy with what it will look like. If it is a simple design that just repeats as a regular block, then I like to check the relationship between the positive space created by the design and the negative space that is left in between. If the design is an all-over affair, which can be slightly more complicated, it will need to be made into a repeating unit that matches itself on all sides. But, like I say, there is no real right and

wrong; it's all about what pleases your eye and what you are happy with.

The projects in this book aim to cover most of the essential design skills that can be accomplished simply by hand. There are some very good software packages for computer-generated designs, but that is a whole different ball game and perhaps a completely separate skill that can be embarked on once the basic principles are understood.

The most important thing about producing your very own designs is how it will make you feel. Not only is it right that your work is not copied *by* anyone else but nor should your work be copied *from* someone else; it will not make you happy knowing that it was someone else's idea. So, while we like to draw on inspiration from other artists and designers, there is nothing more satisfying than coming up with a design that has solely been drawn from your own original mark making. You should always aim to show the development of your designs and credit any artists that have inspired your work.

I have been influenced by many artists and textile designers over the years and my first interest in fabric design can solely be attributed to William Morris. I was learning to make curtains and blinds with the help of a Laura Ashley soft furnishing book and my mother-in-law's electric sewing machine. It was my mother-in-law who found the stall on Barnsley market

Cutting through the horizontal plane to complete the repeating unit for a scatter design.

selling end-of-roll Sanderson fabrics. The first pair of curtains I made were 'Willow' design. William Morris must be in everyone's top ten; even if you are not keen on over-patterned and colourful designs, you have to marvel at how clever he was and how different his work must have been at the time. This also explains why I am inspired by nature and keen only to use plant dyes for my printing.

GETTING STARTED ON A DESIGN

Collecting

The best way to get started is not to think of the end goal, but rather to just spend the time observing what is around you and recording shapes. This is something that you can do all of the time if you have a sketchbook and a pencil with you. I love to take a brand-new sketchpad or notebook and fill it with things I see. The possibilities are endless: the shape of a fence railing, patterns made by the scatter of fallen leaves, end grains of a log pile, a woven rug, a row of plant pots, the shapes inside a cut piece of fruit. If you sit and look for long enough you will see the huge range of forms that can be transformed later into a pattern design, when

you are ready. Eventually you will see shapes and patterns everywhere you go, and sometimes it's quite difficult to switch it off.

Inspiration

We all see things differently: colours, text, styles of drawings and paintings, lines and contours of furniture, planting schemes in the garden. We have our own particular tastes, likes and dislikes, and this is what inspires us. But how do we take this inspiration and allow it to influence our designs? Part of me thinks we don't have to actively do this; it is part of our intuition and we will tend towards an intuitive style, whether it be free-flowing lines, natural forms, motifs, abstracts or geometrics.

We each have a favourite colour; it may have changed over time and with fashion, but we do tend to know what we like and dislike. I love every colour except purple (I have no idea why!). Our ideas about space, if we are minimalist or maximalist, whether we like a big pattern or small intricate patterns… the list can go on. You can easily collect inspirational ideas in a similar way to mark making, using a scrapbook – something I used to do – cutting pictures usually from interiors magazines. But nowadays I find the best way to keep my inspirations together is with my camera on my phone.

Developing a Pattern or Design

Sometimes you may not want to make a flowing repeat pattern; you may just have a single motif or image that you want to develop into a printable format using the screen or block. Often this will involve simplifying the lines and shapes so you can cut a paper stencil or carve a wood or lino block and work out a colour separation.

Collecting ideas in notebooks is a good way to keep everything together and provide inspiration when you are making a new design.

Pattern making is playtime for me! How you go about this has endless possibilities and will vary from designer to designer. The easiest way is with a pencil and piece of paper, although this is rather old fashioned these days. I do eventually turn to Photoshop when my initial drawing of the design is complete. It is useful for scaling up the designs to stencil textile screens. Computer software can be quite expensive and are not really necessary for the simple patterns we will create for hand printing..

Repeating a Design

There are numerous ways in which a design can be repeated. Some are more complicated to achieve than others, depending on the size of the design and how you will print it. Some simple repeats are shown below.

If you are block printing, it is only possible to do mirror repeats by cutting two blocks that are a mirror image of each other. It is easier with stencil prints as the paper stencil can be printed from each side.

Straight block repeat using a grid – the block repeats from side to side and above and below.

Brick repeat – the next row of blocks is offset by half from the first.

Half drop repeat – the next column of blocks is offset by half.

Scatter repeat – for an all-over design

Scale

When you have settled on your final design and have a drawing of the repeating unit, you can play around with the scale. A photocopier can help as a quick way to produce several copies of the repeating unit (tile) at different sizes. You can then stand back and check how a final printed piece will look when finished. You should also check how the positive and negative spaces interact when the blocks are repeating.

Colour

Finally, if you haven't done this part already, you need to think about colour. Will you use more than one colour? For relief printing, each colour will need a different block cutting; and for screen printing, different stencils need to be cut for each colour. This is easily achieved by preparing the artwork for each colour when you have made a master copy of the design; the different coloured components can be traced off one at a time and transferred to the block or paper.

FEATURED DESIGNERS

Vanessa Arbuthnott

Vanessa Arbuthnott's designs have been favourites of mine since I can remember. She started her business on her kitchen table over 20 years ago. Leaving a nursing career to have a family, she accidently found herself on a surface pattern course at Stroud Art College:

> I was immediately hooked. It was like an electric current coming through me… thrilling. It was a passion that I was on a journey with and have never stopped.

Vanessa's approach to a new design starts with what kind of marks she wants to make; either using a drawn line, paper cut-out or a block/lino or potato print.

> I then settle at a trestle table in my kitchen and start brainstorming ideas, working over and over again at the images until I am happy with them.

As a print designer, preferring to work with a block, Vanessa has a tendency to prefer small repeating units, usually in a vertical half drop repeat. As seen in her favourite, latest 'Forest' collection.

> These are my favourites because the very simple motif was cut from a large potato while on holiday on the west coast of Scotland, where I had a wonderful time hand printing and trying out different repeats and scales.

Drawing on the countryside, visits abroad and art galleries for inspiration, Vanessa's favourite textile designers include Lucienne Day:

> Lucienne created the famous Calyx design: it was designed after botanical fabrics, but it was far more styised and abstracted.

She also favoured the Hungarian designer, Eszter Haraszty:

Vanessa Arbuthnott's *Cow Parsley* design has been developed from a drawn line.

Vanessa's *Fruit Garden* design has been developed from the initial cut paper technique.

Vanessa used relief printing for her initial inspiration in *The Herbaceous Border* design.

From Vanessa's 'Forest' collection, '*Little Fern* design was born out of a potato print.'

Eszter was most known for her use of colours, like mixing pinks and orange; an unusual combination for the time.

I asked Vanessa for her top tip when going about making a design. She answered:

Create a fabric or wallpaper you would like to have in your own house. Scale it and colour it and then pin the first samples to your existing curtains… walls… live with them and tweak them as necessary.

New Designer, Alice Broad

I was lucky enough to work with Alice in my studio the summer before she graduated from Loughborough University. Her understanding of surface pattern design and the importance of the printing process in developing ideas is very evident in her work. I love that her hands are the preferred starting point of all of her design processes.

In a time when we are moving towards a digital and artificial intelligence, I consider it more important than ever to produce art that shows the human input and consideration behind pieces. Linocutting allows you to become interactive with the materials, letting the tools become the driving force behind the imagery. I think it is one of the most rewarding processes to see the evolution from an idea and sketch to a design carefully carved away.

Alice Broad has embraced linocut and screen-printing techniques to generate her designs.

Her beautiful designs have developed from things as simple as a colour, a mark, a shape or even a feeling.

I am always influenced by nature. Naturally occurring geography, flora and fauna; I seek unusual quirks, patterns and arrangements. It is so easily accessible and there is an abundance of ideas

Alice's most successful design so far is *Maggie*, her magpie screen print from 'The Crafted Harvest' graduate collection. Its origins have a deep connection with Alice as it celebrates her grandparents' farming heritage and is therefore her favourite design so far.

To honour the physical processes of working on the farm; when my grandfather ploughed the field with horses and my Grandma hand milked the cows; this design contains a wealth of symbolism and storytelling demonstrated through my development and refinement using handcrafted processes such as linocutting, collage and screen printing.
 A reason why it is my favourite is because it has a strong sense of character and mood and it represents a moment where I feel like I have established an identity as an artist. I consider it to pinpoint my evolution from a student to a designer.

Alice Broad's hand carving of her *Maggie* design.

Full drop of *Maggie* design, printed by Alice using a textile size screen.

THE DESIGN PROJECTS

Design Project 7.1: Collecting Marks to Turn Into a Repeating Pattern

DIFFICULTY LEVEL: BEGINNER

This is the sort of project that can be done anywhere: in a waiting room, on a train, in a bar or café, or whenever you need to fill a bit of time or want to draw. You just need a pencil and notebook or a sheet of A3 paper folded into eight rectangles and 30 minutes of time in an inspirational setting. Try not to look for the pattern to start – just draw the shape or marks you see – it can be put straight into your notebook or one of the rectangles on your paper.

When you have eight or so different shapes, look at how they could be transformed into a repeating pattern in some of the projects below, or carry on transforming them in your notebook into pattern ideas.

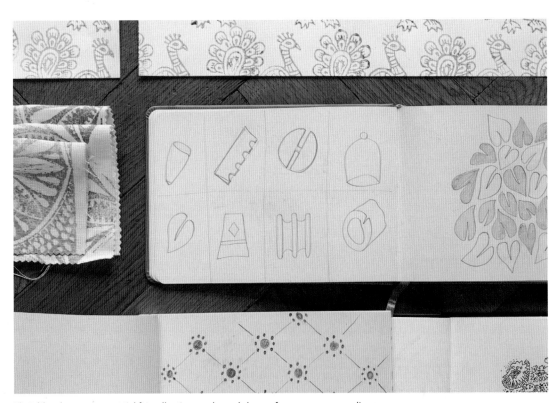

Sketchbooks are an essential for collecting marks and shapes from your surroundings.

DIFFICULTY LEVEL: INTERMEDIATE

Sample designs that could be used for Project 2.2.

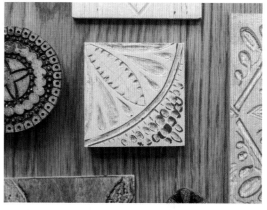

This design was carved into lino that has been ready mounted onto a wooden block.

This is quite an easy process for creating a variety of stunning repeating patterns. You could use any element of the shapes created in Design Project 7.1, as long as the overall design in the square only has one line of symmetry – this works best if it is on the diagonal (*see* examples above).

Finding different ways to repeat the square block to give a range of interesting patterns.

When you have finalised your design as a sketch, you need to draw it out accurately in the right size to fit the block you are cutting from. You can use a simple grid or graph paper to help. Make sure any parts that will join from side to side are aligned. Trace the design onto a piece of tracing paper. Go to Project 2.2 to complete.

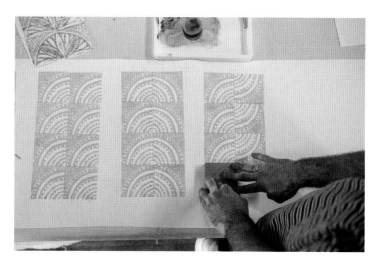

DIFFICULTY LEVEL: BEGINNER

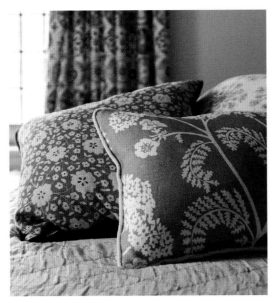

Background prints add more colour to the fabric and look stunning as soft furnishings.

Using cut-up or torn pieces of coloured paper is a very good way to play with design ideas.

This is a lovely way to start screen printing and the finished prints make brilliant pieces for things like cushion fronts and little zip purses. They can also be used to embellish tote bags or even done on paper as a piece of artwork.

For me, these types of prints have been inspired by the work of Matisse from his paper cut-out days. I think this is a very good way to start developing a design. You can start with some simple pieces of coloured sugar paper or paint your own sheets with any type of paint, then use scissors or simply tear the paper into shapes. Arrange them into a border until you have formed a design you are happy with and stick them in place. When you are ready to print, simply trace over the design onto newsprint paper. Go to Project 3.1 to complete.

DIFFICULTY LEVEL: INTERMEDIATE

This method can be used for block or screen printing. You will recognise this type of pattern in geometric tile designs. For the tile to tessellate, the design needs to be symmetrical along the horizontal and vertical planes with the same elements on each side.

Start with a square or rectangle, marked as a grid, to the size you want the final artwork to be. The elements you draw to make your repeating tile can be taken from Project 7.1 or just drawn freely as you wish.

This design can give a variety of different-looking patterns, depending on the type of repeat used. Experiment with brick and half drop repeats, or you could even alternate a straight repeating design with different colours.. Go to Project 2.3 to complete.

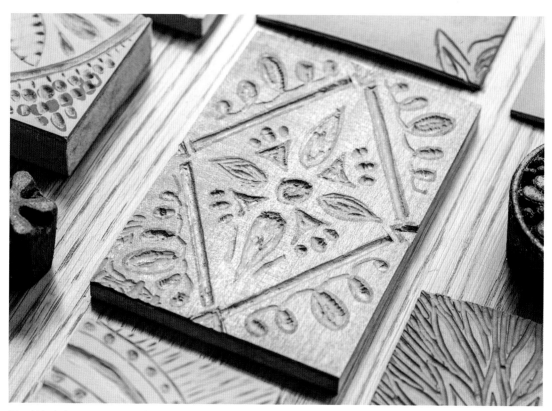

Wood block design that has lines of symmetry through the horizontal and vertical planes.

DIFFICULTY LEVEL: INTERMEDIATE

Printing a design in more than one colour is reasonably easy to achieve once you have made a 'master' piece of artwork. When printing two or more colours using a wood or lino block, you will need a new block for each colour. When screen printing, a new stencil for each colour is required.

Make a master drawing, which is the same size as the final print, and shade to define the different colours. When relief printing, make the design the same size as the blocks you are using. For paper stencils, make sure the design fits comfortably inside the screen to allow for an inkwell at the bottom and top, and both sides. This will allow the squeegee to pass over the whole design in one go.

On the back of a block, mark which way is the top and bottom to help with registration, or you can sketch the design on the back. (It will be the mirror image of the print face but will be how it will look when printed.)

For paper stencils mark an 'X' at the centre, top and bottom and each side, in the same place for all of the colour separation sheets. When centre lines are marked on the fabric being printed, the stencils can be registered using the centre points. Go to Project 2.3 to complete.

For easy registration during printing, mark the orientation of the block on the back.

DIFFICULTY LEVEL: ADVANCED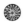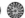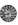

Sticking together the pieces of a scatter repeat master drawing.

The aim of this project is to prepare a design made up of individual elements that will repeat seamlessly to print larger pieces of fabric. This is a good technique to use when putting together a mixture of motif designs, such as different-sized flowers or leaves. In Project 3.3 we will use this method to screen print a larger piece of fabric.

> **NOTE:** When tracing the master block design onto the stencil paper, make sure the design is in the centre so the whole of the screen mesh is covered by paper, ready for printing.

At the drawing stage, this is a repeating unit of a clematis flower design.

1. On a piece of paper that is the right size to fit the internal dimensions of the screen being used, fold or mark into accurate quarters. Draw the motifs being used onto the paper, keeping the edges clear.

2. Cut out the quarters and rearrange them by swapping across the diagonals. Stick the pieces back together with a small amount of tape.

3. Fill the gaps in the design with more of the same or different motifs. Check that the negative and positive space relationship is even and pleasing to the eye.

4. To avoid any misalignments from repeat to repeat when printing, there shouldn't be any shapes that have been cut up. So, next the design is sliced with a wiggly line along the horizontal and vertical planes. The line should go between the shapes as close to the centre of the vertical plane as possible.

5. Now cut along the wiggly line and stick the block back together along the straight edges. Repeat this process for the horizontal plane. You should now have a repeating block with a wiggly edge all round, containing only whole shapes.

6. This block is your master. Using newsprint large enough to cover the screen being used, trace the design into the centre and cut out the stencil a few layers in one go. To repeat print the design, some registration marks will be needed.

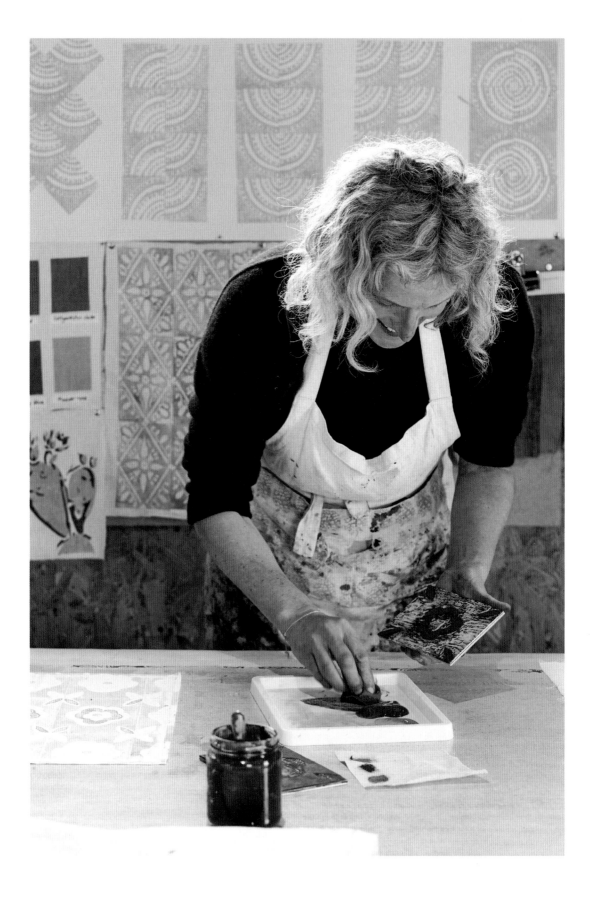

LAST WORDS

I hope this book has given you the first insights into the endless possibilities for printing with natural dyes. It has been a great pleasure to write it and put together some of my favourite projects for you to try at home.

I have a had lot of support during the last few months of putting *Printing with Natural Dyes* together, and along with my family – especially Bertie, Holly and my intern Hayden Mackenzie who were excellent hand models in the photos – I would like to thank my friends who have supported me and not minded my reclusive behaviour. Helen Taylor, my printing partner, for all of her support with the running of Madder Cutch & Co.; Caroline Desbruslais and Sandra Barrowman for help with the writing and grammar; Ashley and Susan from Nature's Rainbow; and Claire and Stephy, founders of Studio Evig, for the supply of lovely dye plant materials.

I owe a huge thank you to my photographer, Lucy Glen, whose professionalism and ability to understand everything in the book without reading it have been remarkable. She has captured the processes and techniques beautifully.

I am so thankful to you for buying a copy and would love to see your creative endeavours, so please keep me updated with your projects by posting on Instagram: #maddercutchandco.

Please enjoy your journey,

Nicola
www.maddercutchandco.com
@ @maddercutchandco

I have had a great time putting the book projects together. I hope you enjoy them as much as I have.

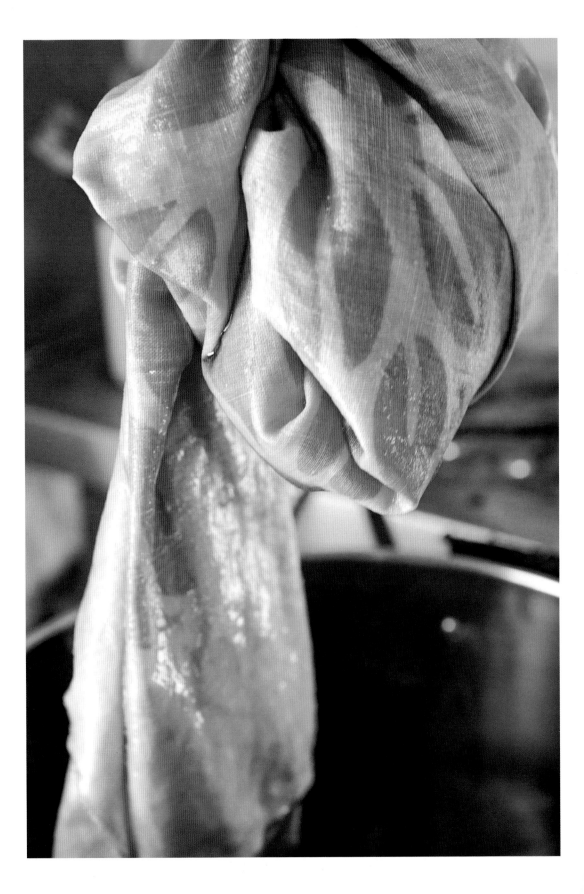

CONTRIBUTORS

Vanessa Arbuthnott Vanessa Arbuthnott Fabrics
www.vanessaarbuthnott.co.uk
[Instagram] @vanessa_arbuthnott_fabrics

Alice Broad Alice Broad textile design
[Instagram] @alicebroad.textiles

Gary Curtis Zerosix Design
www.zerosixdesign.com
[Instagram] @zerosixdesign

Natalie Gerber
www.nataliegerber.ca @natalie_gerber
Photo credits: Studio shot – Kokemor Studio;
fabric shot – Stance Creative

Lucy Glen Lucy Glen Photographer
www.lucyglen.com
[Instagram] @lucyglenphotography

Ink & Spindle
www.inkandspindle.com.au
[Instagram] @inkandspindle_

Jennie Jackson
www.jenniejackson.co.uk
[Instagram] @jenniejacksondesign

Louisa Loakes
www.louisaloakes.com
[Instagram] @louisaloakes

Speronella Marsh Hare's Tail Printing
www.harestail.co.uk
[Instagram] @hares_tail_printing
Photo credits: Rachael Smith

Jacqui Symons Slow Lane Studio
www.slowlanestudio.co.uk
[Instagram] @studioslowlane
Photo credits: Richard Dawson and Artist

Elisabeth Viguie-Culshaw
https://linktr.ee/Bettysbeautifullife
[Instagram] @bettysbeautifullife
Photos by the artist

Ashley Walker and Susan Dye Nature's Rainbow
www.naturesrainbow.co.uk
Photo credits: Ashley Walker

Handprinted
www.handprinted.co.uk
[Instagram] @handprinteduk

Studio Evig
www.studioevig.com
[Instagram] @studioevig

Wild Colours
www.wildcolours.co.uk

BIBLIOGRAPHY AND FURTHER READING

Bechtold, T. and Mussak, R., *Handbook of Natural Colorants* (John Wiley & Sons, 2009)

Bell, G., *The Permaculture Garden* (Permanent Publications, 2004)

Booth, A., *The Wild Dyer: A natural guide to natural dyes & the art of patchwork & stitch* (Kyle books, 2017)

Boutrop, J. and Ellis, C., *The Art and Science of Natural Dyes: Principles, experiments and results* (Schiffer Publishing, 2018)

Burns, S. and Silver, M., *Barron & Larcher: Textile designers* (ACC Art Books Ltd, 2018)

Cave, R., *Impressions of Nature: A history of nature printing* (British Library Publishing Division, 2010)

Dean, J., *Wild Colour: How to make and use natural dyes* (Octopus Publishing Group, 2010)

Delamare, F. and Guineau, B., *Colour Making and Using Dyes and Pigments* (Thames & Hudson, 1990)

Flint, I., *Eco Colour: Botanical dyes for beautiful textiles* (Murdoch Books Pty Limited, 2008)

Garfield, S., *Mauve* (Faber and Faber, 2000)

Mairet, E.M., *Vegetable Dyes: A book of recipes and information useful to the dyer* (Faber and Faber Ltd, 2016)

Nenadic, S. and Tuckett, S., *Colouring the Nation* (NMS Enterprises Limited, 2013)

Parry, L., *William Morris* (Philip Wilson Publishers Limited, 1996)

Websites

angeladesigns.nl/how-to-botanical-contact-prints

bsbi.org/wp-content/uploads/dlm_uploads/Code-of-Conduct-v5-final.pdf

leicesterprintworkshop.com/printmaking/screenprinting/a_brief_history_of_screenprinting

www.natureprintingsociety.org/our-history

palmettoblended.com/blogs/news/a-complete-history-of-screen-printing

wendyfe.wordpress.com – a very good index and starting point if you are keen to delve a lot deeper into artists, processes and plants.

wnybookarts.org/a-brief-history-of-screenprinting

INDEX

DEDICATION

To my brother Haydn, who will always be my best print partner.

First published in 2024 by
The Crowood Press Ltd
Ramsbury, Marlborough
Wiltshire SN8 2HR

enquiries@crowood.com
www.crowood.com

British Library Cataloguing-in-Publication Data
A catalogue record for this book is available from the British Library.

ISBN 978 0 7198 4324 2

Cover design by Sergey Tsvetkov

Graphic design and typesetting by
Peggy & Co. Design
Printed and bound in India by Replika Press Pvt. Ltd.

RELATED TITLES FROM CROWOOD

978 0 7198 4201 6

978 0 7198 4301 3

978 0 7198 4031 9

978 1 78500 145 1

978 1 78500 581 7

978 0 7198 4106 4

978 1 8479 7100 5

978 1 78500 753 8